A concise history of
MODERN SCULPTURE

A concise history of
MODERN
SCULPTURE

Herbert Read

NEW YORK AND TORONTO
OXFORD UNIVERSITY PRESS

Contents

The upshot is that we are not justified in identifying history as a process in homogeneous chronological time. Actually history consists of events whose chronology tells us but little about their relationships and meanings. Since simultaneous events are more often than not intrinsically asynchronous, it makes no sense indeed to conceive of the historical process as a homogeneous flow. The image of the flow only veils the divergent times in which substantial sequences of historical events materialize.

<div align="right">SIEGFRIED KRACAUER Time and History</div>

Author's Note

An author should not begin his book with an apology, but the planning of this concise history of modern sculpture has inevitably meant the omission of the names of many artists of distinction and a brevity of treatment of many others that would not have been justified if my space had been unlimited. For the same reasons of economy I have tended to apply rather a rigid definition to the art itself, and have excluded from the illustrations those reliefs and constructions which hover ambiguously between the crafts of painting and carving. It is not possible to ignore the general tendency to abandon carving and even modelling in favour of various easy methods of *assemblage*, but I cannot pretend to accept this development with complacency.

The illustration of sculpture, for effectiveness, demands a certain scale, and within the limits set by the publisher I did not have room for some of the works I would have liked to include. In making a choice between alternatives I have tried to represent every type of work that is historically significant, but the exclusions were often unfair to artists of considerable achievement.

This volume has been conceived as a companion to the author's *Concise History of Modern Painting*, and it has been assumed that the reader is already familiar with those phases of the modern movement in the arts which all the arts have in common. Otherwise the narrative is quite independent.

As on previous occasions, I would again like to express my great indebtedness to the publications of the Museum of Modern Art, New York, which provide in accessible form much of the essential documentation for the period. I

7

would also like to pay a tribute to the pioneer in this subject, Dr Carola Giedion-Welcker, whose *Contemporary Sculpture: an Evolution in Volume and Space*, first published in 1956 (new and revised edition, 1961), is not only an indispensable work of reference, but also contains a Selective Bibliography by Bernard Karpel of the Museum of Modern Art of great value to the student and the general reader.

Finally I would like to thank all those artists, collectors and art galleries who have helped me to assemble the many photographs required for the illustration of this book. I am particularly indebted in this respect to Mr Joseph H. Hirshhorn, who has allowed me to draw liberally from his own magnificent collection, and to Mr Abram Lerner, the curator of this collection. I have also received considerable assistance from Mr Thomas M. Messer, the Director of the Solomon R. Guggenheim Museum in New York.

It is not usual to thank members of the firm responsible for the publication of a book, but an exception must be made in the present instance. The work could not have been completed without the patient and tireless assistance of Miss Pat Lowman.

February, 1964 H.R.

The Prelude

The history of art like the history of any other subject depends for its coherence on the arbitrary choice of a principle, though 'principle' is perhaps a solemn word for what is no more than a convenience. Against a background of chronological time we have various 'movements' to which we give names like Impressionism, Cubism or Surrealism. These movements do not necessarily follow one another in chronological sequence, and even if they did we should find them criss-crossed by the paths made by individual artists. In other words, the personal development of the artist often traverses two or three movements, and an eclectic artist like Picasso will move in and out of half-a-dozen stylistic categories for no better reason than the one that makes us from time to time seek a change of climate.

We might also say that the history of art is dominated by the works of a few geniuses, and that the minor manifestations of a period are particles on the lines of force that emanate from these fixed points. A chart representing these fixed points and radiating lines (which often meet and merge) would perhaps give us the most accurate image of the historical situation, but it cannot be translated into a verbal narrative. A chronological sequence must be attempted, with the full realization that it is an arbitrary simplification and involves repetitions, contradictions and ambiguous problems of *value*.

In the companion volume on the history of modern painting it was possible to give good reasons for beginning with Cézanne (1839–1906). In sculpture it is tempting to begin with the artist who was his almost exact

9

contemporary, Auguste Rodin (1840–1917). But there is a difference. Cézanne was 'the primitive of a new art'; by concentration on the 'motif', by his patient 'realization' of the inherent structure of the object, he discovered modes of representation that gave solid substance to his perceptual images. He reacted against Impressionism, which had no purpose beyond the rendering of subjective sensations, and could, he thought, only end in meaningless confusion. By his insistence on clarity of form and an architectonic principle of composition, Cézanne laid the foundations of a new classicism, an art of measure and serenity. But Rodin, who began with the ambition to restore the art of the medieval cathedrals, an aim that might have brought him by another path to the same kind of 'masonry', was seduced by the prevailing mood of subjectivism, and could therefore never supply sculpture with the same solid ground for 'a new art'. Rodin was a great artist, and I shall presently describe the kind of rectitude he restored to the art of sculpture; but he was not an originator in the same sense as Cézanne was, and paradoxically the achievements of the painter were to have more significance for the future of sculpture than the achievements of the sculptor. Rodin was followed by Maillol and Bourdelle, who were also great sculptors. But Cézanne was followed by Picasso, González, Brancusi, Archipenko, Lipchitz and Laurens, and it is they who were to be the primitives of a new art of sculpture. This 'new art' will be our concern in this volume, the sculpture we call 'modern' because it is the peculiar creation of our age, and owes little to the art that preceded it in history.

Though the habit is often questioned, there is sufficient excuse for using the word 'modern' to describe a development in sculpture which does not comprise every kind of sculpture that is contemporary. The day on which I write these words I note that a reviewer, Professor Quentin Bell, is questioning this habit; he tells us that the reader of the book he is reviewing (*A Dictionary of Modern Sculpture*):

1 HONORÉ DAUMIER
L'Homme à tête plate
c. 1830–2

will seek in vain for modern sculptors who are not 'modern'; he will find Renoir and Daumier, who for some reason *are* 'modern', but neither Dalou nor Carpeaux, who for some equally obscure reason are not. In short, it is a dictionary of those sculptors who happen to interest the authors and, so long as we realize that, it will cause us no disappointment.[1]

One should perhaps not pay too much attention to a witty remark intended to enliven a review, but I use the word 'modern' with this same restricted meaning and feel perfectly justified in doing so. 'Modern' has been used for centuries to indicate a style that breaks with accepted traditions and seeks to create forms more appropriate to the

sense and sensibility of a new age. From this point of view Dalou and Carpeaux were born 'ancient', and though the traditionalist has a perfect right to be a partisan of the ancient, he cannot deny the use of 'modern' to describe what Harold Rosenberg has called 'the tradition of the new'.[2]

The whole purpose of Rodin had been to restore to the art of sculpture the stylistic integrity that it had lost since the death of Michelangelo in 1564. Three centuries of mannerism, academicism and decadence stretch between the last great work of Michelangelo, the *Rondanini Pietà*, and the first confident work of Rodin, *The Age of Bronze* of 1876–7. It is true that in the interval there is the odd intrusion of Honoré Daumier, who as early as 1830 was producing busts as superficially 'modern' as any works of Rodin. But Daumier was a caricaturist, and the kind of deformations made by the caricaturist to secure his satirical emphasis have nothing in common with the formal conceptions of a Rodin (as the satires of Goya, for example, have only a superficial resemblance to Picasso's drawings for his *Guernica*). Caricature itself is a relatively modern form of art (it was not known to the world before the end of the sixteenth century), but already in 1681 it had been defined as:

> a method of making portraits, in which they (painters and sculptors) aim at the greatest resemblance of the whole of the person portrayed, while yet, for the purpose of fun, and sometimes of mockery, they disproportionately increase and emphasize the defects of the features they copy, so that the portrait as a whole appears to be the sitter himself while its component parts are changed.[3]

Any resemblance with the stylistic forms of modern art is therefore 'purely coincidental'.

The principles of sculpture to which Rodin returned were clearly stated by the artist himself on many occasions. They may be conveniently consulted in the *entretiens* (conversations) collected by Paul Gsell.[4] Rodin resumed these

AUGUSTE RODIN *The Age of Bronze* 1876-7

principles in a 'testament' of less than two thousand words, which, apart from exhortations to love the great masters of the past (particularly Phidias and Michelangelo), to have an absolute faith in Nature, and to work relentlessly, gives the following advice:

> Conceive form in depth.
> Clearly indicate the dominant planes.
> Imagine forms as directed towards you;
> all life surges from a centre,
> expands from within outwards.
> In drawing, observe relief, not outline.
> The relief determines the contour.
> The main thing is to be moved, to love,
> to hope, to tremble, to live.
> Be a man before being an artist!

These are the words of a humanist, of an artist who was always concerned to serve humanity and to give his work a public setting. His ideals, social and artistic, were the same as those of Phidias and Michelangelo, the same as those of the 'image-makers' of the Middle Ages, of whom, he said, Michelangelo was the heir.

It is important to keep these ideals in mind if we are to measure the extent to which modern sculpture has abandoned them in order to substitute other ideals. In general we may say that two developments have taken place, one of which continues to 'conceive form in depth' and generally to follow the tradition of the image-makers, the other rejecting the humanist tradition as such together with its organic criteria, in order to create values of a different kind, the absolute values of 'pure form'. For all his modernity a sculptor like Henry Moore remains within the same formal tradition as Michelangelo; a Constructivist like Naum Gabo has quite other ideals. We continue to call all free-standing three-dimensional works of plastic art 'sculpture', but the modern period has seen the invention of three-dimensional works of

14

art which are in no sense 'sculpted' or even moulded. They are built up, like architecture, or constructed like a machine. It will be necessary to elucidate these distinctions and seek to justify them aesthetically.

Two modifications of the organic tradition that preceded the modern period should next be noted, those stylistic phases known as Impressionism and Eclecticism. Whether Rodin is to be called an Impressionist depends on one's definition of Impressionism. We do not immediately associate him with the Impressionist movement as such, though he once exhibited with Monet (at Petit's, in 1889)[5] and he owned Van Gogh's *Le Père Tanguy*, now in the Musée Rodin. Like most labels in the history of art, 'Impressionism' covers a multitude of individual styles, and it is not easy to isolate a quality common to artists so diverse as Cézanne, Degas, Manet, Pissarro and Renoir. As Mr Rewald suggests in his definitive history of the movement, 'no one word could be expected to define with precision the tendencies of a group of men who placed their own sensations above any artistic program'.[6] If one accepts the then current definition of one of Renoir's friends (G. Rivière), 'treating a subject in terms of the tone and not of the subject itself', then it is difficult to apply it to the work of Rodin, or to sculpture in general. Even if one accepts Mr Rewald's amended definition – 'rejecting the objectivity of realism, they had selected one element from reality (light) to interpret all of nature' – one still has painting rather than sculpture in mind (and even then it is difficult to fit a painter like Cézanne into the definition, for he regarded light as a deceptive or ambiguous element in the representation of form). As for Rodin, though he thought of light as the element in which form was revealed, it was not '*la vérité intérieure*'. The inner truth of growth and form is revealed to touch rather than to sight; touch at least has the sensational priority, and if it is objected that the spectator does not normally apprehend

15

3　MEDARDO ROSSO　*Conversazione in Giardino*　1893

sculpture by this means, it is the spectator's loss. The sensations involved in the act of creation are essentially those of thrust and pressure, tactile sensations.

This distinction would not exclude an impressionistic sculpture, for the definition changes with the material. Nevertheless, one is much nearer the truth of the matter if one concentrates on movement rather than light, and movement was equally the concern of the painters and sculptors involved. Rodin realized that the *illusion* of life could not be given except by the representation of movement. Movement he defined as the transition from one attitude to another, and this could not be rendered 'realistically' in a piece of sculpture, which is a static object. The alternative is to

16

4 AUGUSTE RODIN
Monument to Balzac 1897

suggest successive positions simultaneously. An instantaneous photograph, he maintained, was deceptive because it illustrated an arrested movement; but the artist was interested in movement itself, and this could be represented only by certain conventions. He therefore defended Géricault who painted racehorses with their four legs simultaneously extended, which never occurs in reality but is indicative of the sensation experienced in watching a race. The artist depicts his visual feelings, which may be illusory, but the result is nearer to the truth than any photograph.

One might say, therefore, that Rodin sympathized with those aspects of Impressionism that were based on '*la vérité intérieure*', on subjective feeling, but would have

17

nothing to do with those aspects based on a science of visual perception. In this respect he differed radically from such Impressionists as Seurat and Pissarro, who for a time attempted to base their methods of painting on the optical theories of Chevreul, Maxwell and other physicists. If Rodin's statues were so realistic that he could actually be accused of casting his *Age of Bronze* from a live model, this was not because he had any ideal of photographic accuracy, but because the representation he made corresponded exactly to the sensations he experienced. In this sense he was a realist, but an ambiguity remains, due to the fact that the truth is often stranger than fiction, fiction being, in this case, the prevailing academic conventions. There are at least three possibilities: 1. the counterfeiting of reality (mimetic representation), 2. the representation of the visual experience, and 3. the creation of various substitutes (signs, symbols) for such experience. If the Impressionist is one who attempts to be faithful to the visual experience, then Rodin was an Impressionist in such works as *The Age of Bronze* (1876–7) and a Symbolist in such a work as the final version of the *Monument to Balzac* (1897).

The modernity of Rodin lies in his visual realism. There were, of course, realists in sculpture before Rodin. In this sense Michelangelo was a realist, and above all Donatello. But the significance of Rodin for the sculptors who came after him lies not so much in his fidelity to his visual experience, still less in the humanistic prejudice he always displayed, but solely in the integrity of the technical means he employed, his almost blind reliance on his tools. A gulf separates the work of Rodin from that of Arp or Henry Moore; but all three sculptors share the same concern for the virtues proper to the art of sculpture – sensibility to volume and mass, the interplay of hollows and protuberances, the rhythmical articulation of planes and contours, unity of conception. The ends differ but the means are the same, and most modern sculptors recognize that it

18

was Rodin who brought back to the art of sculpture a
proper sense of sculptural values. The nature of this
achievement has been beautifully described by the poet who
was for a short time the sculptor's secretary, Rainer Maria
Rilke:

There is above all the indescribably beautiful bronze
portrait bust of the painter Jean-Paul Laurens, which is
perhaps the most beautiful thing in the Luxembourg
Museum. This bust is penetrated by such deep feeling,
there is such tender modelling of the surface, it is so fine
in carriage, so intense in expression, so moved and so
awake that it seems as if Nature had taken this work out

19

6 CHARLES DESPIAU
Head of Madame Derain 1922

7 MEDARDO ROSSO *Ecce Puer* 1906–7

of the sculptor's hands to claim it as one of her most precious possessions. The gleam and sparkle of the metal that breaks like fire through the smoke-black patina coating adds much to make perfect the unique beauty of this work.[7]

Rodin's immediate successors in France, Aristide Maillol (1861–1944), Antoine Bourdelle (1861–1929) and Charles Despiau (1874–1946) do not concern us, except in so far as they maintained these sculptural values for another generation. Bourdelle worked for a long time as Rodin's chief assistant and Maillol, before he became a sculptor at the age of forty, was attracted to Impressionism as a painter or

8 ANTOINE BOURDELLE
*Beethoven, grand
masque tragique* 1901

designer. But both sculptors returned to classical idealism
(Maillol lived in Greece for a year) and both reacted against
Impressionism. 'Nature is deceptive,' said Maillol. 'If I
looked at her less, I would produce not the real, but the
true. Art is complex, I said to Rodin, who smiled because
he felt that I was struggling with nature. I was trying to
simplify, whereas he noted all the profiles, all the details;
it was a matter of conscience.'[8] This ingenuous confession
reveals the difference between the two artists. Despiau also
worked for Rodin, but he confined himself almost ex-
clusively to portraits and, sensitive as these are, they did
not contribute anything to the future development of
sculpture.

6

9 GEORG KOLBE 10 ARTURO MARTINI
Young Girl Standing 1915 *Boy Drinking* 1926

More unreservedly impressionistic in his style than
Rodin is the Italian sculptor Medardo Rosso (1858–1928).
He was born in Turin and like Maillol began as a painter.
He was in Paris from 1884–5 and worked in the studio of
Dalou. He met Rodin from time to time and may even have
influenced him – it has been suggested that his *Conversazione
in Giardino* (1893), a large sculptural group dominated by a
figure turning its back, inspired Rodin in his *Monument to
Balzac* (1893–7).[9] But Rosso was a social realist as well as
an Impressionist – perhaps an Impressionist because he
wanted to catch the actuality of daily life rather than because
he had any scientific theories about illusion and reality. In

3

4

this respect he is closer to Degas, whom he knew personally, than to Rodin or Maillol, and it is significant that Zola was one of his early patrons. His realism had led him to revolt against a static conception of sculpture. In group compositions like the *Conversazione* his style is distinctly manneristic and violent. It is this quality in Rosso's work, rather than the serenity of his portraits, that was to attract the Futurists who from 1909 onwards hailed him as a pioneer of 'dynamism' in art. Boccioni in particular was strongly influenced by Rosso.

There are several other sculptors of this generation, caught between Impressionism and classicism, refusing the challenge of modernism as first revealed in Cubism, who nevertheless, by their very eclecticism, contributed to the

7

11 GERHARD MARCKS
Freya 1949

12 ERNESTO DE FIORI
The Soldier 1918

revival of sculpture. Rosso's compatriot and contemporary,
10 Arturo Martini (1889–1947) is one – a sculptor little known
outside Italy (except possibly in the United States). Martini
was trained as a potter and his most characteristic works
are in terracotta. They recall certain Renaissance works in
that medium (for example, the terracottas of Antonio
Rossellino). But they are more mannered, and a certain
'mannerism' is characteristic of all this group of 'hesitants' –
13, 12 Wilhelm Lehmbruck (1881–1919), Ernesto de Fiori (1884–
9, 11 1945), Georg Kolbe (1877–1947), Gerhard Marcks (b.
14 1889), Renée Sintenis (b. 1888) – it is significant that so
many of them are of German origin, and I can think of no
better explanation than the continuing influence of that
great German classicist, Adolf Hildebrand (1847–1921).
Hildebrand did not think of himself as a classicist, but

13 WILHELM LEHMBRUCK *Young Man Seated* 1918

14 RENÉE SINTENIS
Football Player 1927

rather as a humanist reviving the best traditions of Renais-
sance sculpture. I have discussed his theories elsewhere;[10]
in my opinion they had a disastrous influence on European
sculpture because they elevated visual and pictorial values
above the essential sculptural values which are tactile and
haptic. Mannerism in modern sculpture has no other origin.
On the credit side it must be granted that Hildebrand's
emphasis on direct cutting as distinct from modelling had a
good effect on the purely technical development of the art.
But a good technique cannot save a false aesthetic.

 In a rather different category is the German sculptor
Ernst Barlach (1870–1938), who also insisted on the 17
virtues of carving as distinct from modelling. But Barlach
deliberately rejected the classical tradition in favour of the
Gothic or Nordic tradition. In some degree this brings him
nearer to Rodin with his admiration for the image-makers of

the Middle Ages, but Rodin was sensitive enough to feel the classical element in mature Gothic, and he might have claimed that Gothic only reached its maturity when, as at Reims or Augsburg, the Abstract Expressionism of the Northern 'will to form' combined with the idealistic naturalism of the Greek tradition to achieve a new and higher synthesis of styles. In other words, Barlach and Rodin had very different 'image-makers' in mind. Barlach really belongs to Expressionism – at least, his Gothic forms were modified by expressionistic tendencies just as Rodin's classic forms were modified by impressionistic tendencies. In his early work, the ceramic figures of 1903–4 and the terracotta and bronze figures of 1906–7, there is a distinct element of the prevailing *Jugendstil* (*art nouveau*), but that is true of the early stages of German Expressionism in general. These generalizations apply equally to the work of two other German sculptors who may be associated with Barlach – Gerhard Marcks and Käthe Kollwitz (1867–1945). Kollwitz, better known as a graphic artist, was nevertheless a sculptor with great understanding of plastic form, and

11, 15

15 KÄTHE KOLLWITZ
The Complaint 1938

16 LEONARD BASKIN
Head of Barlach 1959

one of great compassion. Marcks began as an animal
sculptor 'until, at the sight of finches in the zoo, despair
seized me'.[11] His native Nordic feelings have been to some
extent modified by classical influences, but it should not
be forgotten that Gropius called him to the Weimar Bauhaus
in 1920, where he remained until the Bauhaus was closed
five years later (to reopen in Dessau). He was persecuted by
the Nazis and included in the infamous exhibition of
Degenerate Art.

17 ERNST BARLACH
Veiled Beggar Woman 1919

18 PIERRE BONNARD
Girl Bathing c. 1923

19 EDGAR DEGAS
Pregnant Woman c. 1896–1911

Rodin apart, it could be said that the most significant
contributions to the evolution of modern sculpture before
the advent of Cubism were made by two painters – Degas
and Matisse. The sculpture of painters is a fascinating
subject, inclining to paradox. That sculpture can be com-
bined with painting without detriment to the exercise of
either craft is sufficiently proved by the case of Michelangelo.
In the case of the artists now to be considered, Degas,
Gauguin, Renoir, Bonnard and Matisse, we are concerned
with painters whose main preoccupation was the art of
painting, for whom sculpture was either an amusement or a
test in another medium of their passionate involvement in

plastic values – the rendering of volume in space, the conflict of light and mass. It is difficult to regard the sculpture of Gauguin (1848–1903), for example, as more than a diversion from his main purpose. For the most part in the form of reliefs, it does not claim to be more than decorative, except perhaps in two or three small statuettes, such as the figure (27½ inches high) in painted wood, *Caribbean Woman* (*La* 43 *Luxure*), carved at Le Pouldu in 1890–1. The same figure appears in a painting, *Caribbean Woman with Sunflowers*, of 1889–90 (Collection of Dr and Mrs Harry Bakwin, New York).[12] The sculpture adds nothing of aesthetic significance to the painting; it was apparently inspired, according to Mr Rewald, by a fragment of a frieze in Gauguin's possession that had fallen from a building in the Javanese village that was part of the Universal Exhibition of 1889.

Auguste Renoir (1841–1919) and Pierre Bonnard (1867–1947) had more feeling for the tactile values of sculpture,

20 AUGUSTE RENOIR
Standing Venus (*Venus Victorious*) 1914

21 EDGAR DEGAS *Dancer, Arabesque over right leg, right arm in front* 1882–95

and their few pieces are well modelled in the tradition of
18 Rodin or Maillol. Bonnard's *Girl Bathing*, a bronze of about
1923, is sensitive enough to be mistaken for a Rodin.
Renoir did not attempt sculpture until late in life (1907), and
most of his work was done with an assistant, Guino, in the
last five or six years of his long life, when he had begun to
experience difficulty in handling a paint-brush. Neverthe-
20 less the bronze *Standing Venus* (*Venus Victorious*) of 1914
does succeed in translating into solid three-dimensional
form the grace and tenderness of his paintings.

The cases of Degas and Matisse are quite different. Both
took an essential part in the formation of a new type of
sculpture, and had a profound influence on their successors.
A considerable distance in time separates these two artists.
Degas was born in 1834 and died in 1917; Matisse lived
from 1869 to 1954. They made their first attempts at sculp-
ture at about the same age, in their early thirties. Degas did

30

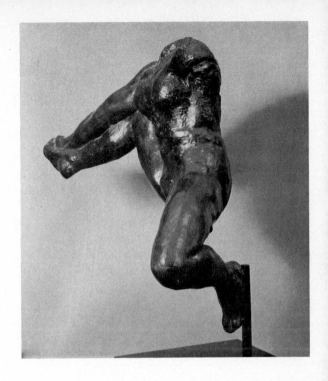

22 AUGUSTE RODIN
Iris, Messenger of the Gods
1890–1

not exhibit any sculpture before 1866; Matisse's first sculpture dates from 1899.

It would be possible to distinguish the two artists sculpturally by describing them as Impressionist and Post-Impressionist, but there was a more fundamental difference of aim. For Degas sculpture was never more than ancillary to his painting, but ancillary in the sense that through its means Degas was able to explore problems of form and movement which he found difficult to solve in the two-dimensional medium of painting. His bronze dancers and horses are always part of and contemporary with his pre-occupation with these motifs in his painting. This brought him near to Rodin, and there is in fact little distinction to be made between Rodin at his most impressionistic, say the *Iris, Messenger of the Gods* (1890–1), and a Degas representation of a similar motif, such as the *Dancer, Arabesque over right leg* (1882–95). Nevertheless, when Degas exhibited his

22

21

23 *Little Dancer* at the sixth Impressionist exhibition in 1881 (it was the wax original now in the possession of Mr and Mrs Paul Mellon) it was to strike a contemporary like Huysmans as 'the only really modern attempt of which I know in sculpture'.[13]

Matisse's reaction to Impressionism is quite another story – the story, indeed, of Post-Impressionism in general. Matisse as a young man had admired Rodin from a distance. In 1906 (according to André Gide's *Journal*, repeating an anecdote told him by Maurice Denis) Matisse had been to Rodin's studio for the first time and had shown him some of his drawings. Rodin had told him to persevere (*pignocher*) for a fortnight with the same drawings and then show them to him again.[14] Matisse himself told rather a different story to Raymond Escholier:

> I wanted to know what Matisse himself had to say about his relations with Rodin, and he also defined the gap which separated their different conceptions of sculpture, and art itself. 'I was taken to Rodin's studio in the rue de l'Université, by one of his pupils who wanted to show my drawings to his master. Rodin, who received me kindly, was only moderately interested. He told me I had "facility of hand", which wasn't true. He advised me to do detailed drawings and show them to him. I never went back. Understanding my direction, I thought I had need of someone's help to arrive at the right kind of detailed drawings. Because, if I could get the simple things (which are so difficult) right, first, then I could go on to the complex details; I should have achieved what I was after; the realization of my own reactions.
>
> 'My work-discipline was already the reverse of Rodin's. But I did not realize it then, for I was quite modest, and each day brought its revelation. . . . Already I could only envisage the general architecture of a work of mine, replacing explanatory details by a living and suggestive synthesis.'[15]

23 EDGAR DEGAS *The little Dancer of fourteen years* 1880–1

24 HENRI MATISSE
The Slave 1900–3

25 HENRI MATISSE
Madeleine I 1901

Matisse's criticism of Rodin is that he neglected the whole (monumentality) for the sake of the carefully realized detail – that he conceived the whole as an assemblage of such details. Matisse knew instinctively that wholeness has a quality of its own which differs from the sum of the parts, and that it was more important to capture this unique quality of wholeness than to get lost in the study of detail. Detail, that is to say, should be strictly subordinated to the creation of a dominant rhythm. As in his painting, so in his sculpture; Matisse is in search of 'ease', harmony, of what he called the arabesque. His reaction to Maillol's work is significant in this respect. He was much more closely related to Maillol – indeed, they were intimate friends, but

34

HENRI MATISSE
Serpentine 1909

27 HENRI MATISSE
Decorative Figure 1908

28 HENRI MATISSE
Jeanette V 1910–11

29 HENRI MATISSE *Large Seated Nude* 1907

Matisse was never influenced by Maillol. On the contrary –
as he told Escholier, he had practised sculpture, 'or rather
modelling', before he knew Maillol:

> I did it as a complementary study to put my ideas in
> order. Maillol's sculpture and my work in that line have
> nothing in common. We never speak on the subject. For
> we wouldn't understand one another. Maillol, like the
> Antique masters, proceeds by volume, I am concerned
> with arabesque like the Renaissance artists; Maillol did
> not like risks and I was drawn to them. He did not like
> adventure.[16]

This is a very revealing confession. Arabesque, a word often
on Matisse's lips, is a linear conception; it is also, in its

36

Oriental origins, a decorative conception. It is an escape from mass and volume, towards movement or action, and that, of course, with many qualifications (for Matisse was a master of suggestion, that is to say, of the first principle of Impressionism), is also true of his painting.

Nevertheless, Matisse took his sculpture seriously. It has often been related how he made his first piece, a free copy of Barye's *Jaguar devouring a Hare* – how he worked for months in a studio at the École de la Ville de Paris, dissecting a cat to get a realistic knowledge of the anatomy of such an animal. His first human figure, *The Slave* of 1900–3, might be mistaken for a free copy of Rodin's *Walking Man*, but again it was based on detailed observation of the model. In the contemporaneous *Madeleine I* he has already broken away from his predecessors, and the result is indeed an 24 25

30 HENRI MATISSE *Seated Nude* 1925

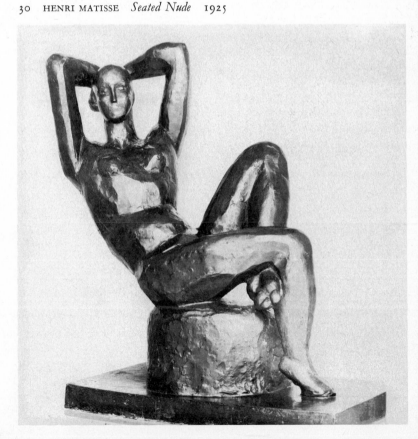

arabesque – a human body deprived of arms and features to emphasize its sinuous curves.

All Matisse's most characteristic sculptures – the 29, 27 *Large Seated Nude* of 1907, the *Decorative Figure* of 1908, *La* 26, 28 *Serpentine* of 1909, the series of *Jeanette* busts (1910–11), the 34, 32 *Reclining Nude II* of 1929, the *Venus in a Shell* of 1931, are arabesque in the sense claimed by Matisse. But they are also increasingly 'haptic', emphasizing by distortion the inner muscular tensions of the human figure. One has only to compare a graphic and a sculptural representation of the same model – for example the lithograph of a *Nude in an* 30 *Armchair* (1925) with the *Seated Nude* of the same year in the Baltimore Museum – to see how certain features, such as the lower extremities of the legs and the arms held behind the head, are used to produce tensions that give the pose the visual effect of balance. The same features in an even more exaggerated form are found in *La Serpentine* as early as 1909. This expressionistic tendency in Matisse's sculpture – a

31 HENRI MATISSE *Tiari with Necklace* 1930 *(left)*

32 HENRI MATISSE *Venus in a Shell* 1931 *(right)*

33 HENRI MATISSE
Reclining Nude I
1907

HENRI MATISSE
clining Nude II
29

HENRI MATISSE
clining Nude III
29

tendency not generally found in his painting, which shows how carefully he observed the distinct sensational values involved in each art[17] – comes to a climax in the series of 36–9 'Backs' he experimented with from 1909 to 1929. Though we are concerned with reliefs and not with sculpture in the round, the series does nevertheless summarize the complete evolution of Matisse's stylistic development in this art. The 36, 24 first *Back* is almost as naturalistic as *The Slave* and repeats the 25, 37 arabesque of *Madeleine I*; the second is rather more summary or 'brutal', but there is no essential departure from the 38 human model. But the third *Back*, which was apparently made immediately after the second, shows drastic simplifications of form. The limbs have become rigid trunks and a long 'tail' of hair descends from the head to balance the 39 upward thrust of the legs. In the final version, which followed after an interval of fifteen years, the forms have become simplified to a degree rarely found in the paintings – the *Bathers by a River* of 1916–17 in the Henry Pearlman Collection and the figure of the painter in *The Painter and His Model* of 1916 (Paris, Musée National d'Art Moderne) are

36 HENRI MATISSE
The Back I c. 1909

37 HENRI MATISSE
The Back II c. 1913–14 (?)

the nearest equivalents. Two smaller pieces of free sculpture, the *Reclining Nude III* of 1929 and the strange *Tiari* of 1930 (a 35, 31 tiari is a tropical plant; its form is combined with a human head) show that Matisse was in this year experimenting in a direction that brought him curiously near to the altogether different conception of the sculptor's art represented by Arp and Henry Moore.

How intimately and sensuously Matisse grasped the basic principles of the art of sculpture is shown by some notes which Sarah Stein took down when she attended Matisse's lectures or demonstrations at the 'Académie Matisse', a school run by Matisse in Paris from 1908–11. They have been reproduced in Alfred Barr's monograph on the artist.[18] The following four instructions reveal the fundamentally expressionistic bias of Matisse's conception of art:

See from the first your proportions, and do not lose them. But proportions according to correct measurement are after all but very little unless confirmed by sentiment, and expressive of the particular physical character of the model. . . .

HENRI MATISSE
Back III c. 1914

39 HENRI MATISSE
The Back IV c. 1929

All things have their decided physical character – for instance a square, and a rectangle. But an undecided, indefinite form can express neither one. Therefore exaggerate according to the definite character for expression. . . .
The model must not be made to agree with a preconceived theory or effect. It must impress you, awaken in you an emotion, which in turn you seek to express. You must forget all your theories, all your ideas before the subject. What part of these is really your own will be expressed in your expression of the emotion awakened in you by the subject. . . .
In addition to the sensations one derives from a drawing, a sculpture must invite us to handle it as an object; just so the sculptor must feel, in making it, the particular demands for volume and mass. The smaller the bit of sculpture, the more the essentials of form must exist.

There are many more detailed observations taken down by Sarah Stein which show Matisse's profound understanding of sculpture – for example: 'Arms are like rolls of clay, but the forearms are also like cords, for they can be twisted.' And: 'The pelvis fits into the thighs and suggests an amphora.'

On another occasion[19] Matisse summed up all his experience and his philosophy of art in a sentence that has often been quoted but cannot be repeated too often: *L'exactitude n'est pas la vérité.*

Very few sculptors can be associated directly with Matisse, and in general it can be said that the influence that changed the course of Impressionist (and Expressionist) painting changed the course of sculpture. These influences were partly *eclectic* or *exotic*, the impact of types of sculpture from outside the European tradition, and partly *revolutionary* – the revolution in question being the Cubist one, which, however, gave impetus to a further revolution (which in its turn may have received contributory influences from other sources), the Constructivist revolution.

42

Eclecticism

Eclecticism is an attitude in art that permits a free choice and combination of styles other than one's own; *exoticism* implies that these styles are borrowed from a culture other than one's own. The distinction need not be pressed, for even when an artist borrows from a primitive source in his own civilization (early Greek, Romanesque, Etruscan in European art), these periods are usually remote enough to seem exotic, and the same artist (Picasso, for example) makes no distinction between primitive and exotic sources. There is perhaps an ethical distinction between the two procedures – to borrow from a remote source does not seem to have the same implication of plagiarism as borrowing from a contemporary source. If the borrowed style is thoroughly assimilated, its source has little aesthetic significance.

The past hundred years have witnessed the injection of at least seven exotic styles into the main stream of modern art. They may be listed as follows:

1. Far Eastern art.
2. African tribal art.
3. Primitive art (folk art, child art, naïve art).
4. Prehistoric art (especially neolithic carvings).
5. Pre-Columbian art of America.
6. Early Greek and Etruscan art.
7. Early Christian (especially Romanesque) art.

There may be still other minor influences, such as Celtic art or Polynesian art, but these fall into the general pattern.

Before tracing the impact of these influences on modern sculpture it might be interesting to attempt to find a reason for such eclecticism. It is not, of course, altogether a new

43

phenomenon: art has always been subject to influences and otherwise would scarcely have a history. Archaeology is the science that attempts to trace all the elements of 'independence, convergence and borrowing' involved in the history of culture, and to this process gives the name of cultural *diffusion*. When such diffusion occurs in the field of art, e.g. the spread of Greek art to India, or of Buddhist art from India to China, it is in an historical process, taking place in time, often lasting centuries. Eclecticism is a more restricted process, and though it may have political or economic origins, it is manifested as individual choice rather than as historical necessity. For example, the *chinoiserie* of the seventeenth and eighteenth centuries was a consequence of the growth of the trading with the Far East that took place at that time. Porcelain and embroidered silks were imported along with tea and spices, and the ornamentation on these objects was available to individual European artists as a source of motifs. But there was no unconscious assimilation of an Oriental style powerful enough to modify the general development of European art. In the same way, the importation of Japanese prints in the second half of the nineteenth century, which had such a decisive effect on Gauguin, Van Gogh and Whistler, did not change the course of the main stream of artistic development in Europe. The style of a few artists was modified, often only for a short time or even only in a few works. An artist like Gauguin received confirmation from Japanese art of certain principles he had evolved from inner necessity, just as he also received confirmation of other stylistic features from such sources as medieval stained glass, folk art, primitive coloured woodcuts and other sources. Such sources 'converge' in the sensibility of one artist, but a receptive sensibility is the necessary prerequisite. That sensibility is the end-product of a complex process, partly deriving from the individual artist's psychological constitution, partly from what might be called the available colours on the palette, the palette

44

PABLO PICASSO *Mask* 1901 41 PABLO PICASSO *Head of a Woman* 1907

being the artist's consciousness of the social forces prevailing in his environment.

When a sufficient number of artists submit to the same influences, what is usually called a 'revival' may take place, as in the Renaissance (a 'rebirth' of classical art). The Gothic Revival of the early nineteenth century was in its turn a revolt against this classical tradition, and the fact that two such 'revivals' could contend with each other shows that an arbitrary element of choice is involved. This is still more evident in the eclecticism of the last hundred years. But a romanticist might suggest that the real conflict is between, not romanticism and classicism, but between romanticism and esotericism. The romantic artist always claims to be 'original'.

The esotericism present in the modern movement since the beginnings of Post-Impressionism and Expressionism

45

42 PABLO PICASSO
Head of a Woman 1951

has never dominated modern art. One reason is that it has
been too various – an artist has been offered too many
alternatives and has often, as notably in the case of Picasso,
decided to try them all. The only question is whether, in
any particular case, such diverse influences have been
assimilated, or whether they have merely produced a frag-
mentation of the artist's sensibility.

We are concerned at present with the art of sculpture, but
it is precisely this art, because of its perdurability and trans-
portability, that has been most effective as an agent of
stylistic diffusion. In the case of some of the civilizations
concerned, painting was not practised, or has not survived
in significant quantities (except, perhaps, as mural decora-

46

43 PAUL GAUGUIN *Caribbean Woman (La Luxure)* 1890–1

tion), whereas the sculpture is plentiful and is now to be found in all the important museums of the world. After pottery, the most indestructible of all arts, sculpture has been the main agent of stylistic diffusion in modern times.

I have already mentioned how Gauguin made a carving of a *Caribbean Woman* based on a fragment from a Javanese building in the Universal Exhibition of 1889. This exhibition was a decisive event in the history of modern art, and Van Gogh was impressed no less than Gauguin. He wrote to Émile Bernard about it:

43

You know, there is something I am very sorry not to have seen at the Exhibition; it is a series of dwellings of all the peoples. . . . Now look here, could you, since you

have seen it, give me an idea, and especially a coloured sketch of the primitive Egyptian house. . . . I saw in one of the illustrated papers a sketch of ancient Mexican dwellings; they too seem to be primitive and very beautiful. Ah, if only one knew the dwellings of those times, and if only one could paint the people who lived in the midst of them, it would be as beautiful as the work of Millet; I don't say in the matter of colour, but with regard to character, as something significant, something one has a firm faith in.[1]

There are one or two points to note in this extract. First, what is primitive is found to be beautiful – 'as beautiful as the work of Millet'. Further, such art is not merely beautiful: it has 'character' and gives one 'firm faith' – faith in the significance of art, faith in humanity.

In a letter to his brother Theo of 9 June of this same year, which also refers to the exhibition, Van Gogh defines more precisely what he means by 'faith':

Now what makes Egyptian art, for instance, extraordinary – isn't it that these serene, calm kings, wise and gentle, patient and kind, look as though they could never be other than what they are, eternal tillers of the soil, worshippers of the sun?

. . . the Egyptian artists, having a *faith*, working by feeling and instinct, express all these intangible things – kindness, infinite patience, wisdom, serenity – by a few knowing curves and by the marvellous proportions. That is to say once more, when the thing represented and the manner of representing agree, the thing has style and quality.[2]

There were two reasons why primitive art should have made such a strong appeal to Gauguin[3] and Van Gogh – first this feeling of 'faith' which it gave to these anguished artists, faith not in the doctrinal sense, but simply faith in nature, in life. During this century artists and poets and philosophers

48

44 GEORGES BRAQUE *Horse (Gelinotte)* 1957

(Nietzsche, Ibsen, Marx) everywhere in Europe were becoming aware of the tragic alienation that had been caused by the growth of industrialism. Van Gogh was acutely aware of the contrast revealed in the simple, serene, and monumental works of primitive people. But he then perceived that this effect on him was made by purely formal means. He had no intellectual key to the doctrines of these primitive people and did not need one: the faith was implicit in the forms. It was the sculpture itself (the architecture and all these primitive artefacts) that emanated confidence in nature, kindness, existential calm.

Therefore it became a question of once more trying to work by feeling and instinct, a question of discovering forms that expressed 'the intangible'. From that moment

49

45 CONSTANTIN BRANCUSI
Bird 1912

the historical destiny of the modern movement was fixed –
fixed by the greatest pioneer of this movement. We must
always return to Van Gogh if we would understand the
origins of modern art – to Van Gogh and Gauguin, who
at the same time had experienced in Tahiti 'a delight dis-
tilled from some indescribable sacred horror which I
glimpse of far-off things . . . the odour of an antique joy . . .
animal shapes of a statuesque rigidity: indescribably antique,
august and religious in the rhythm of their gesture, in their
singular immobility'.

The interest in primitive art that began with Van Gogh
and Gauguin grew from year to year. Van Gogh died in
1889. In 1891 Gauguin went to Tahiti, and apart from a
return to Europe in 1893 stayed there and in the Marquesas

46 CONSTANTIN
BRANCUSI
Adam and Eve
1921

47 CONSTANTIN
BRANCUSI
*Torso of a Young
Man* 1924
(*far right*)

Islands until he died in 1903. But the idea of the primitive
had penetrated deeply into the consciousness of French
artists. By 1904 the painter Vlaminck was taking an interest
in primitive art, and from Vlaminck the interest passed to
Derain and from Derain to Matisse. Both Derain and Matisse
began to collect Negro sculpture before 1907, and according
to Gertrude Stein[4] it was to Matisse that Picasso owed his
first knowledge of African sculpture. An uninterrupted
chain of influences from Van Gogh to Picasso is thus
established.[5]

I have already suggested why all these artists were drawn
to primitive art in the first place. The interest has continued
to grow for the same reason. The explanation, as I wrote on
a previous occasion,[6]

lies in mankind's return to a 'primitive' state of mind . . . modern man, and the modern artist in particular, is no mere eclectic monkey, trying to imitate for his occasional amusement the artefacts of primitive races; on the contrary, he is, spiritually speaking, in a tough spot himself, and the more honest he is with himself, the more resolutely he rejects the traditional shams and worn counters of expression, and the more nearly, and the more unconsciously, he finds himself expressing himself in a manner which bears a real and no longer superficial resemblance to so-called 'primitive' art.

Most of the exotic influences I have described are 'primitive' in the sense defined by Van Gogh – they proceed from works that are the expression of feeling and instinct – simple, serene, devoid of all intellectual sophistry. Other exotic influences on the development of modern art have been more complex, simply because they come from a phase of a past civilization that is itself more complex. There is, after all, a difference of both style and quality between African Negro sculpture and Egyptian sculpture, a still greater difference between Negro sculpture and Greek sculpture of the geometric period. Etruscan sculpture also belongs to a relatively sophisticated civilization and Mexican sculpture of the kind that affects our sensibility may belong to the decadence of that highly complex civilization. Very few modern artists have sought in exotic art a simplicity 'as beautiful as the work of Millet'. Rather they have been attracted by its remoteness and its mystery, even its complexity. This is certainly true of Far Eastern art, the extremely refined expression of a metaphysical outlook that has nothing in common with the art of Africa or Tahiti. We know very little of the religion and philosophy of the Incas and Mayas, but again it was complex rather than simple, fearful rather than serene. Even when we come to the primitive art of our own Christian civilization, to Romanesque or

JEAN ARP *Landmark* 1938 49 JEAN ARP *Ptolemy I* 1953

Gothic art (both fundamental influences on Picasso and Henry Moore), we are in the presence of spiritual qualities that have quite a different metaphysical significance. But two qualities perhaps all these exotic arts have in common – their remoteness in time and the symbolic nature of their representations. Modern man has been in search of a new language of form to satisfy new longings and aspirations – longings for mental appeasement, aspirations to unity, harmony, serenity – an end to his alienation from nature. All these arts of remote times or strange cultures either give or suggest to the modern artist forms which he can adapt to his needs – the elements of a new iconography.

Imitation is not his purpose, but always assimilation and regeneration. The whole 'drive' in any purposive will to form (the only rational explanation of artistic development) is towards an equilibrium of inner feeling and the outer world of experience, and the work of art functions as the realization of such an equilibrium. It is thus a symbol of reconciliation, of appeasement, and it serves such a purpose more effectively when it is 'abstracted' both from the immediacy of our feelings and from the immediacy of an objective or impersonal world. The work of art therefore functions best (and this is its normal function throughout history) when it acts as a bridge between the two worlds of feeling and perception, giving definition to feeling and form to perception. This was the whole significance of Cézanne's heroic struggle with his sensations, and it was he, more than any other artist of the nineteenth century, who laid the foundations of the modern movement.

Cubism was not one more phase in the evolution of art – an evolution corresponding to social and economic trends: it was a decisive break with tradition. For five centuries European art in all its phases had been committed to *representation*; from the advent of Cubism onwards it was committed to quite another aim, that of *substitution*.[7] That is to say, the representation of the phenomenal image given in visual perception was abandoned as the immediate *motif* of the artist's activity, and in its place the artist elaborated a symbol, which might still retain reminiscences of, or references to, the phenomenal object, but no longer sought to give a faithful report of the optical image.

This is not the place to enter into the reasons for this revolutionary change in the development of art: I have given my own explanation in other books.[8] But it is not possible to appreciate the fundamental nature of the changes that came about in the early twentieth century, particularly in the art of sculpture, without realizing that the individual artist was carried away in currents that were

PABLO PICASSO *Bouquet* 1953

51　JEAN ARP　*Shell and Head*　1933

beyond his control. He might pull back from time to time, to consolidate what he had already gained, as Picasso and Braque pulled back from the logical extreme of Cubism, i.e. an abstract art. But the action of these artists is not to be interpreted as a withdrawal from the revolutionary enterprise, but merely as a refusal to take one particular path for fear it led to a dead end. The revolution as it proceeded dis-

52　HENRY MOORE　*Reclining Figure*　1938

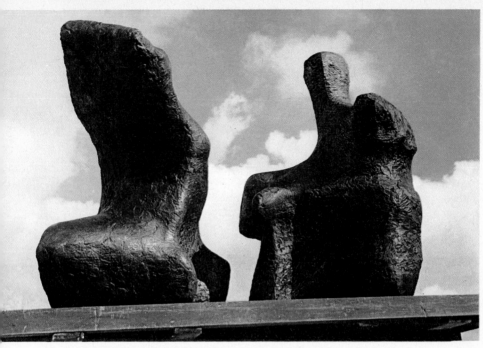

HENRY MOORE *Two-piece Reclining Figure, no. 1* 1959

persed its energies in various directions, but all the artists involved continued to be guided by the same purpose: to find symbols to symbolize their inner feelings, which feelings they shared with mankind everywhere.

That their search often became esoteric is easy to understand. A symbolic art, an art of substitution, had prevailed for long epochs in the past, and it was natural, therefore, to seek in the past either symbols that might still be serviceable, if adapted to contemporary sensibility (such as those Cycladic statues of the Mother Goddess that symbolize an everlasting archetypal feeling), or, more generally, a confirmation of the fact that inner feelings could be objectified in symbols that had no other function. This does not imply that illusory images of the 'real' world can never have a symbolic function – at some epochs, notably in Europe from the fifteenth to the nineteenth century, they served this

57

purpose adequately. But the effectiveness of symbolization is determined by the metaphysical ground of our existence, and that ground in the modern age is similar to what it has often been in other civilizations – obscure, fragmented, without confidence in nature or man. In such a human condition we seek a style in art that gives us a sense of security, of permanence, of vitality, of immediate sensuous enjoyment. Since we do not find these qualities in the objective world, the world of industry, of poverty, alienation and war, we seek it in works of art that renounce the objective world. We seek deliverance, as Worringer says, 'from the fortuitousness of humanity as a whole, from the seeming arbitrariness of organic existence in general, in the contemplation of something necessary and irrefragible. Life as such is felt to be a disturbance of aesthetic enjoyment.'[9] But such aesthetic enjoyment is not an escape from life. On the contrary, it is an affirmation of the deepest instincts of life against their frustration by the inhuman forces of an industrial civilization.

These principles (not cold conceptual dogmas, but profound metaphysical intuitions) will become clearer as we review the work of the great sculptors who have contributed so much to their realization in the forms of art – Picasso, Brancusi, Arp, Gabo and Henry Moore, to mention only the most originative of them. I shall confine myself to the historical developments as they unroll in chronological sequence, but movements are rough generalizations, often the improvisations of journalists and critics rather than of the artists themselves, and the work of the greatest of these sculptors defeats all categories, whether of time or place or nationality. The modern artist, by nature and destiny, is always an individualist.

From Cubism to Constructivism

'Cube', which was used spontaneously by critics and journalists to describe the immediate effect of the paintings exhibited by Braque and Picasso from 1910 onwards,[1] is a word which suggests a three-dimensional object rather than a painted canvas. From the beginning of the movement it was obvious that sculpture no less than painting was involved in the new adventure. There is no need to describe the general history of the movement in the present context, but it sprang from the confluence of two of the sources mentioned in the preceding chapters, the paintings of Cézanne and the tribal sculpture of Africa. Whether Picasso or Braque had priority in effecting this fusion is an idle question that has been much discussed. The two artists came together (introduced to each other by Apollinaire) towards the end of 1907. At that time Picasso had already painted *Les Demoiselles d'Avignon*, without doubt the most revolutionary work of art in the history of the modern movement, and at first Braque shared the general bewilderment produced by this painting.[2] But the two artists soon became intimate friends and from 1908 onwards were virtually living and working together. In general we might say that of the two influences that combined to form the new style, one, primitive art, and in particular Negro sculpture, was represented by Picasso; the other, the art of Cézanne, by Braque. It has been pointed out (by Jean Revol, for example) that Braque, though fascinated by Negro sculpture, never assimilated its style directly into his painting.[3] And equally Picasso was never profoundly affected by what is essential in Cézanne's style, his search for solidity, for 'plenitude' as

54 PABLO PICASSO *Head of a Woman* 1909–10

Cézanne called it. There was therefore an essential conflict between the styles of Picasso and Braque when they began to work together in 1908, and although Picasso had already made superficial use of motifs from Cézanne (even in *Les Demoiselles*), it was not until he met Braque that he began to see the significance of Cézanne, and made the necessary connection between Cézanne's form in depth and the

55 PABLO PICASSO *Glass of Absinthe* 1914

simplification of surfaces in Negro and Romanesque sculp-
ture. The one 'point of view', he suddenly realized, could
be combined with the other to produce the necessary
synthesis of two-dimensional movement (dynamic pattern)
and three-dimensional volume. The probability is that
Braque arrived at this synthesis slightly ahead of Picasso –
his landscapes painted at L'Estaque in the summer of 1908

56 PABLO GARGALLO *Picador* 1928

seem to anticipate Picasso's Cubist landscapes painted at Horta de San Juan a year later, though the first intimations of Cubism were already present in *Les Demoiselles d'Avignon* a year earlier.[4]

Picasso's first quasi- or proto-Cubist sculptures were three carvings in wood made in 1907, but the first fully Cubist piece is the bronze *Head of a Woman* of 1909–10. This is a direct realization of the methods already evolved in painting a three-dimensional object (see, for example, the *Seated Nude* of the same year in the Tate Gallery). This head is an impressive work of art, in which the aims of Cubism (to create 'a scaffolding of planes', to use Henry Kahnweiler's expressive phrase, that would cause light to reinforce the impression of solid structure rather than destroy it – always Cézanne's problem) are successfully attained.

Why then does this piece remain the solitary master-piece of sculpture in Picasso's Cubist period? When he resumed sculpture three years later he was already off on

54

57 JULIO GONZÁLEZ *Cabeza Llamada el Encapuchado* 1934

another line of exploration, one that was to continue throughout his career, *assemblage* – that is to say, the construction of sculpture from miscellaneous ready-made materials. The explanation is one that concerns his general development at this period (1910–13). It was a retreat from abstraction, to which a conceptual approach to painting was inevitably leading him. The abandonment of Cubism by Picasso and Braque is usually attributed to the outbreak of war in August 1914, but the nearest point to abstraction in the work of Picasso had been reached earlier, in 1912–13. From this year onwards he became more and more interested in the surface texture of the painting: the Cubist ideal of 'pure form' was gradually 'adulterated' by a whole battery of miscellaneous objects – pasted paper, linoleum, pieces of wood and string – all kinds of devices that tended to produce an effect which Alfred Barr has called 'rococo'. Out of this development came the first piece of sculpture produced by assemblage – the *Glass of Absinthe*, which is a 55

bronze (8¾ inches high) cast from a model of wax on which a real spoon has been balanced. If we ignore the models designed for the ballet *Parade* it is the only piece of three-dimensional sculpture produced by Picasso between 1910 and 1925. When Picasso resumed 'sculpture' it was with constructions in iron and wire which belonged to an altogether new and unprecedented type of art.

As far as Picasso is concerned, this new direction was suggested by his fellow-Catalan, Julio González (1876–1942). González had gone to Paris in the same year as Picasso, 1900, and had soon formed a friendship with him which was to last all the rest of his life. For fifteen years he lived a solitary life as an unsuccessful painter, but in 1927 he began

58 PABLO PICASSO
Construction (Head)
1930–1

59 JULIO GONZÁLEZ *Mascara de
Montserrat Gritando* 1936

60 JULIO GONZÁLEZ
Hombre-Cactus, no. 2 1939–40

to experiment with wrought iron. This was not Picasso's
first introduction to metal sculpture, for he was an intimate
56 friend of another Spaniard, Pablo Gargallo, who had shared
a studio with him in Barcelona in 1901, and again in 1906
when he followed Picasso to Paris. Gargallo's first sculp-
tures in iron date from 1911[5] and Picasso was perfectly
familiar with these early works (mostly masks which in their
turn owe something to African prototypes). Gargallo's
masks, incidentally, may have given Picasso the idea of
open-work sculpture (Kahnweiler makes a distinction be-
tween open-work sculpture, generally made open for
decorative purposes, and transparent sculpture, made to
display the exterior and interior of an object simultaneously,
55 as in the *Glass of Absinthe* of 1914). But in so far as metal
sculpture is concerned Picasso's relation to González was
54 much more direct. The *Head of a Woman* of 1909–10 had been

61-5 PABLO PICASSO
Stick-statuettes 1931

modelled in González's studio and in 1931, having moved to a château in the country where there was plenty of space for such an activity, Picasso asked his old friend to teach him the necessary technique. Between 1930 and 1932 Picasso 58 made at least fifty pieces of metal sculpture. They vary greatly in style, but two completely original inventions emerge, to constitute prototypes for the future development of the art of sculpture. A third type, though not without precedents in antiquity, was in effect an innovation.

At Boisgeloup, the country house already mentioned, Picasso began to extend the idea of 'assembling' actual objects and raw materials which he had already used for reliefs to three-dimensional constructions:

> Pieces of scrap-iron, springs, saucepan lids, sieves, bolts and screws picked out with discernment from the rubbish heap, could mysteriously take their place in these

66 PABLO PICASSO *Construction in wire* 1930

ALEXANDER CALDER *Calderberry Bush* 1932

constructions, wittily and convincingly coming to life with a new personality. The vestiges of their origins remained visible as witnesses to the transformation that the magician had brought about, a challenge to the identity of anything and everything.[6]

This is Roland Penrose's description of the procedure involved in this new type of sculptural construction, and it will at once be seen that it has nothing in common with the aims of the Russian Constructivists, whose constructions were far from having 'magic' as their aim. A Constructivist 'construction', as evolved by Tatlin, Gabo and Rodchenko, was deliberately *impersonal*, and the spatial relations it created were as abstract as a mathematical formula – it has often been noted that they approximate, unintentionally, to the visual models constructed by scientists to illustrate an algebraic formula. Picasso's iron figures, however, have definite emotional attributes – they are sinister, mysterious, or even humorous. There may have been no conscious intention to create anything analogous to a tribal idol or totem, but that is the effect achieved. They possess the kind of magic we associate with the animistic cults of primitive races.

As such, far from being irrelevant to our sophisticated civilization, they seem to meet a long-felt need. Elsewhere I have called them the icons of a scientific age, and to understand this kind of sculpture we must first dismiss the rationalistic prejudice which sees magic as a force belonging to a past stage of civilization, as a kind of pseudo-science preceding the true science whose benefits we now rather doubtfully enjoy. Magic is not, and never has been, a substitute for science, but is rather a constructive activity with a specific social function,[7] and one that is still operative. The interpretation of magic as primitive science, typical of Tyler, Frazer and other anthropologists of the last century, has since been replaced by a theory which sees it as a permanent feature of collective groups, closely allied to art. According to anthropologists like Malinowski and Levi-Strauss and to a philosopher like Collingwood, the aim of magical objects and magical rites is to arouse emotion in the group and to make such roused emotions effective agents in the practical life of the community. 'The primary function

of all magical arts,' says Collingwood, 'is to generate in the agent or agents certain emotions that are considered necessary or useful for the work of living. . . . Magical activity is a kind of dynamo supplying the mechanism of practical life with the emotional current that drives it. Hence magic is a necessity of every sort and condition of man, and is actually found in every healthy society.' He points to many of our daily activities, not only religious ceremonies and military parades, but also fox-hunting and football, as essentially ritualistic activities undertaken as social duties and surrounded by all the well-known marks and trappings of magic – 'The ritual costume, the ritual vocabulary, the ritual instrument, and above all the sense of electedness, or superiority over the common herd, which always distinguishes the initiate and the hierophant.'[8]

Even in 1938, when Collingwood published his *Principles of Art*, he could note that 'a recrudescence of magical art is going on before our eyes'. He does not give examples, but he probably had in mind jazz music and dancing as well as the works of painters like Picasso. Thirty years later we can find thousands of examples to illustrate and prove Collingwood's theories. I confine myself to magical sculpture, for there can be no doubt that the makers of such sculpture aim to create objects which focus and crystallize emotions that are not so much personal as public, and stand in relation to society, not as representations of the external world, much less as expressions of the artist's personal consciousness or feeling, but rather as catalysts of a collective consciousness. Mass emotions are not so much symbolized discretely, but rather given a disciplined outlet in organized ritual. We must remember that the beginnings of this new development in sculpture coincide with the heyday of Surrealism, and the Surrealists were also insisting on the creation of magical objects, many of which were classified as sculpture. As early as 1917 Kurt Schwitters and Arp had constructed magical objects, often out of rubbish, and they

71

68 JUAN GRIS *Harlequin* 1917

69 ROGER DE LA FRESNAYE
Italian Girl 1912

carried this activity over into the Surrealist movement, where it was adopted by other sculptors (see Chapter Four). The typical Surrealist sculpture, as made by Max Ernst or Giacometti in the late twenties or early thirties, is not to be distinguished from Picasso's sculpture of the same period, except from the point of view of technique. The same can be said of some of Brancusi's work of this period (*Le chef*, 1925, for example) and of Henry Moore's early work. Indeed, it was largely through sculpture that this animistic trend entered the modern movement, to constitute one of its main characteristics.

Before I follow up this trend, I would like to refer briefly to two of the other inventions introduced by Picasso at this

72

time. One is curious and short-lived – the elongated 'stick-
statuettes' which Picasso in the year 1931 whittled from long thin pieces of wood and then had cast in bronze. They would scarcely be worth mentioning, but they bear a superficial resemblance to those elongated figures of men and limbs which Alberto Giacometti began to make fifteen years later. The carving technique differs from Giacometti's modelling technique, which has more affinity with the elongated figures found in Etruscan and Iberian tombs. Giacometti is also concerned with movement and space, whereas Picasso's figures are more magical in intention. But the comparison with Giacometti gains in plausibility when we consider the third and more important of Picasso's innovations – the wire 'space cages' which he constructed in

61–5

146–7

66

ALEXANDER ARCHIPENKO
nan with a Fan 1914

71 HENRI LAURENS
Head 1917

72 RAYMOND DUCHAMP-VILLON
Head of Baudelaire 1911

73 ALEXANDER ARCHIPENKO
Seated Mother 1911

74 RAYMOND DUCHAMP-VILLON
Seated Woman 1914

75 JACQUES LIPCHITZ *Head* 1915 76 JACQUES LIPCHITZ *Guitar Player* 1918

1930.[9] The idea is to define space by wire outlines – a 'drawing in space' – which is a complete denial of sculpture's traditional values of solidity and ponderability. According to Kahnweiler, Picasso intended these constructions, which are only about 12¾ inches high, to be models for large monuments, into which human beings could enter and so be aware of the space outlined. Rodchenko and other Russian Constructivists had had the same ideas as early as 1920, but there is no reason to suppose that Picasso was aware of their experiments. But through Picasso the idea spread, to Giacometti (e.g. *The Palace at 4 a.m.*, 1932–3) and then to Alexander Calder (b. 1898; in Paris 1929–32), whose

95

142
67

77 OSSIP ZADKINE
Standing Woman 1920

78 HENRI GAUDIER-BRZESKA
Red Stone Dancer 1914

mobiles are 'space cages' of wire that move in order to create ever-changing spatial relations. Since that time many other variations of wire sculpture have been evolved, notably the gossamer constructions of Richard Lippold (b. 1915). But such constructions tend to move towards pure abstraction, whereas Picasso and Giacometti always include some reference to human forms or activities.

I have by no means exhausted the sculptural inventions of Picasso, but from 1930 onwards he was to be more and more exclusively preoccupied with *magic*: he is concerned to represent in his figures certain vital forces of social significance – the *anima* that we project into all subjects, animate or in-

286

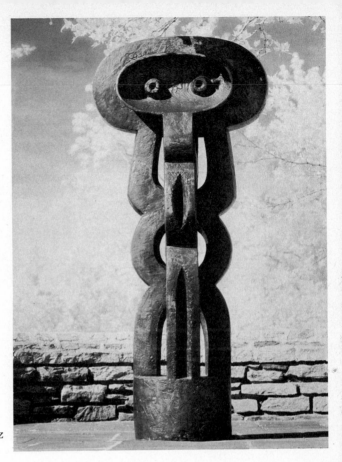

79　JACQUES LIPCHITZ
Figure　1926-30

animate, the quality the Chinese call *ch'i*, the universal force
that flows through all things, and which the artist must
transmit to his creations if they are to affect other people.
This *vitalism*, as I prefer to call it, has been the desire and
pursuit of one main type of modern sculptor. It has little
or nothing in common with the quality that has been the
desire and pursuit of the other main type of modern sculptor,
the Constructivists, the quality we may call *harmony*, or if we
are not afraid of an ambiguous word, *beauty*. Henry Moore
and Naum Gabo may be taken as typical representatives of
these two distinct aesthetic ideals, and I propose to antici-
pate a fuller consideration of their work and give a brief

77

80 CONSTANTIN BRANCUSI *Sleeping Muse* (1st version) 1906

81 CONSTANTIN BRANCUSI *Sleeping Muse* 1909–10

82 AMEDEO MODIGLIANI
Head 1912 (?)

characterization of their respective aims and achievements
in the present general context. But before I do so I must pay
tribute to that other great artist already mentioned, whose
work embodies more precisely and perhaps more deliberately
than any of the pioneers of modern sculpture the universal
element of spirituality I have just referred to: Constantin
Brancusi (1876–1957). Brancusi came to Paris from Rumania
in 1904, the year in which Picasso finally decided to settle in
Paris. His work eventually attracted the attention of Rodin,
who asked him to become his assistant, but Brancusi
refused. He preferred solitude and simplicity, ideals which
he had derived from the mystical treatise of the eleventh-
century Tibetan monk, Milarepa.

79

It is difficult to trace the influence that Brancusi undoubtedly exercised on the development of modern sculpture, because his works are relatively few and were rarely exhibited. But in 1909 he became an intimate friend of Amedeo Modigliani (1884–1920), the Italian painter and sculptor who came to Paris in 1906. Modigliani was pri-
82 marily a painter, but he practised sculpture under the direct tutelage of Brancusi, and his style, even in his paintings, is closely related to Brancusi's. Modigliani's paintings were destined to attract more attention than his sculpture, and after his tragic death his fame spread throughout the world. But Brancusi, too, attracted much attention, some of it hostile; from 1926 to 1928 he was involved in a lawsuit with the United States Customs Service, which had refused to ad-
130 mit his *Bird in Space* duty-free as a work of art, maintaining that it was taxable as a piece of metal.

Brancusi's early work is mannered and not free from traces of the *art nouveau* sophistication of the period (the early
80-1 versions of the *Sleeping Muse*, 1906–10, and of *Mademoiselle*
83 *Pogany*, 1913). But his form evolves under two compelling ideals – universal harmony and truth to materials. Universal harmony implies that form is determined by physical laws in the process of growth. Just as the crystal takes on a determinate form, or a leaf or a shell, by the operation of physical forces on matter animated by an internal energy, so the work of art should take form as the artist's creative energy wrestles with the material of his craft. The egg, for example, takes on its ovoid shape by virtue of the mechanical forces which operate during its growth, gestation and delivery. When Brancusi conceived a symbol in marble for *The Beginning of the World* (1924), it assumed an egg shape. This was perhaps a reduction of the process of art to an imitation of natural processes, and it might be possible criticism of Brancusi that the forms he reaches by this reductive process are too jejune, too simple and summary. But simplicity and purity were his ideals, and he never passed beyond the

CONSTANTIN BRANCUSI *Mademoiselle Pogany* 1913

limits of organic vitality: his simple forms, of fish or bird, are alive. But simplicity is only one of several possible virtues in vital objects: the human form, for example, without sacrificing any of its complexity, can express the same ideals of vitality and harmony.

This is, indeed, the lesson we learn when we pass from the work of Brancusi to that of Henry Moore (b. 1898). Moore may have been momentarily influenced by Brancusi, though I doubt it – Picasso would again provide more immediate data from the Boisgeloup period. Nor can we ignore, as I have done so far, the influence of another great innovator, Jean Arp (b. 1887), whose work has always been inspired by these same ideals of organic form. Arp's Dada and Surrealist period is an influence apart, but from 1931–2 (contemporaneously with Picasso's Boisgeloup period) he began to concentrate on sculpture in the round, modelling and carving in stone and wood, and from this time onwards his sculpture, equally with Brancusi's, became an attempt to represent 'the secret ways of nature'. Arp began to call his sculptures

84 JACQUES LIPCHITZ *Benediction I* 1942

85 JEAN ARP *Human Concretion* 1933

concretions, which he defined as 'the natural process of con-
densation, hardening, coagulating, thickening, growing to-
gether. . . . Concretion is something that has grown. I
wanted my work to find its humble, anonymous place in the
woods, the mountains, in nature' (unfortunately it was
usually destined to find its place in that most unnatural
environment, a public art gallery).

 Moore, too, has expressed a desire to have his sculpture
placed in the open, and some of his works have found a
natural setting on moors and in parks. But Moore's work is
much more complex than Brancusi's or Arp's, and its com-
plexity proceeds from its humanity – its involvement in
human destiny. Moore has been obsessed from the beginning
with two or three archetypal themes – the reclining figure,

85

172

165

167, 173

161 the mother and child, the family – not deliberately, but from some inner compulsion, some drive from the unconscious. If Moore had merely illustrated such themes, in the manner of academic artists, his work would not have become so significant. But he combined his mythological motivation with the same respect for the secret ways of nature as Brancusi and Arp. In fact, there are two forces operative in the sculpture of Moore, which I would call the vital and the mythical. From the vital source comes everything represented by Arp's word 'concretion' – formal coherence, dynamic rhythm, the realization of an integral mass in actual space. From the mythical source comes the mysterious life of his figures and compositions, in one word, their *magic*. And it is this quality that allies him, not only with Picasso, but also with all the magical and ritual art of the past – the art of Babylon and Sumer, of Egypt and the Aegean, of Mexico and Peru, of Africa and Oceania.

86 OTTO FREUNDLICH
Composition 1933

HENRI LAURENS *Reclining Woman with raised arms* 1949

I shall return to Moore, and to the sculptors that may be said to have followed him into this world of magic, in a later chapter. But first I must resume the main theme of the present chapter, which is to trace the origins and development of Cubist sculpture. Apart from some superficial elements that may have been derived indirectly from Picasso and Brancusi, this stylistic development owed nothing to African sculpture and pursued an aim which from the first was quite distinct from that of the Cubist painters. It began in Moscow and was at first independent of wider European influences.

It is unwise to claim originality for any images or ideas in this age of swift extensive communications: a discovery made in Paris, Milan or New York is immediately common property, and this is true especially of discoveries in significant expression. The whole world is waiting for novelties, whether in scientific experiment, medicine or modes of living (housing, clothing, entertainment). The modern artist is affected, however unconsciously, by this restless research, and it is inevitable that his work should reflect such a universal mood. Art has always been a symbolizing activity,

85

88 PABLO PICASSO *Mandolin* 1914

VLADIMIR TATLIN *Corner Relief* 1915

and though in the past such activity was restricted to the sphere of myth and religion, it continues unabated in our materialistic age. Mankind has an insatiable need for icons – for signs, symbols, emblems, slogans – images and metaphors of every kind. It is not surprising, therefore, that the most significant feature of our civilization – the machine – should itself become a symbol: a symbol of power, dynamism, speed, all the ideal concepts of our mechanized way of life.

Cubism itself, from this point of view, is a mechanic reaction to the fluidity and organicism of Impressionism. Picasso's *Head of a Woman* of 1909–10, which corresponds, 54

of course, to the 'analytical' paintings of the same period, was inspired by his desire to avoid the disintegration of structure and volume that takes place in Impressionist painting and sculpture. In spite of his concern for the traditional values of sculpture, even Rodin, in his later work, had tended to sacrifice integral volume or solidity for the sake of the visually impressive effect of highlights. Such use of light in sculpture tends to destroy the palpable, the ponderable and tactile values of the mass – its solidity is dissolved in a purely visual delight. This, to Picasso, was the weakness inherent in Impressionism, and like Cézanne, though by more drastic means, he wished to recover the sense of structure, of permanency, of precision. He said to Henry Kahnweiler at this time: 'I'd like to paint objects so that an engineer could construct them, after my pictures,' and Kahnweiler comments: 'To replace "engineer" by "sculptor" is to realize that sculpture transposed onto a plane surface was what Picasso was driving at, taking into account, of course, all the "distortions" imposed by such a transposition. . . .'[10]

This desire expressed by Picasso, to paint objects 'so that an engineer could construct them', shows that he too, as an artist, was subject to the tendency to idealize the machine, to make the machine itself a symbolic icon. He was not himself to pursue this aim, for he realized that the age demanded spiritual compensations for the alienation of man caused by the machine – in other words, an art of the unconscious, a magical art. But whenever he made this remark to Kahnweiler – and it seems to have been about 1909–10 – he was predicting a development that was to take place more or less immediately, with Moscow as its centre.

'Creative engineering', as we might call it, is an ideal born with the industrial revolution, and Paxton's Crystal Palace and Brunel's bridges are the primitives of a constructive art. The Futurists were perhaps the first artists to accept the machine age as an aesthetic ideal, but as we shall see,

90 ALEXANDER RODCHENKO
Construction 1917

91 VLADIMIR TATLIN
Relief 1914

they worshipped the *concepts* of power and speed represented by the machine rather than its products. But from 1914 onwards a group of artists in Moscow attempted to apply engineering techniques to the construction of sculpture, and the objects thus made were called 'constructions'. The chief promoter of this new development was Vladimir Tatlin (1885–1953), originally a painter. Perhaps mainly thanks to an enthusiastic collector of contemporary French paintings in Moscow, Sergei Shchukin, the Moscow artists at this time had an up-to-date knowledge of the *avant-garde* movements in Paris, and Tatlin and his rival, Kasimir Malevich, quickly went through a development that included Impressionism, Post-Impressionism and analytical Cubism.

89

Late in 1913 Tatlin succeeded in realizing his ambition, which was to go to Paris and visit Picasso. He saw Picasso several times – indeed, suggested to Picasso that he might stay with him as an assistant, a proposal that did not appeal to Picasso. Tatlin returned to Moscow, but he had seen and been inspired by the reliefs in sheet iron, wood and cardboard that Picasso was making at the time.[11] These represent,

88 in a very arbitrary manner, guitars, wine-glasses and other such objects, but the similar reliefs made by Tatlin on his return to Moscow have no such representational motive –

91 they are the first completely abstract constructions.[12]

Tatlin had taken a hint from Picasso but deliberately went further in his explorations, now following the Italian Futurists. This influence was proclaimed in the title of an exhibition held in Petrograd in February 1915: 'The Futurist Exhibition: Tramway V', in which Tatlin showed six 'Painting Reliefs'.[13] Picasso's reliefs remained 'painterly'; that is to say, extensions in depth of the two-dimensional picture plane. The object of the experiment was to develop the range of painting, not to create a new type of sculpture. But Tatlin did conceive precisely that possibility – a new type of sculpture – a sculpture that would take raw materials and ready-made objects and arrange them in 'real' space without any representational intention. The materials, each with their own plastic qualities, the specific qualities of wood, iron, glass, etc., would compose into a work of art, 'real materials in real space'. Within a year or two the construction had been emancipated from the picture frame, and for a

89 background Tatlin would take the corner of a room, and sling the construction on a wire between the walls, the intersecting planes of the walls playing an essential part in the spatial construction.[14]

Tatlin was not alone in these experiments, though he may have been the leading spirit after his return from Paris. As an innovator he had been preceded by Kasimir Malevich (b. 1878, therefore seven years older than Tatlin). But

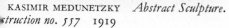

KASIMIR MEDUNETZKY *Abstract Sculpture.* 93 LEV BRUNI *Construction* c. 1918
truction no. 557 1919

Malevich, who as a painter went through even more distinct
phases of development than Tatlin, contributed little to the
art of sculpture except his influence. He passed from
Expressionism to Cubism, and then about the same time
that Tatlin went to Paris and came under the influence of
Picasso, Malevich began to work out his theory of geo-
metrical abstraction, to which he gave the name Suprema- 97
tism. He may have been influenced by Kandinsky,[15] or by
Worringer's theory of abstraction and empathy (first
published in Munich in 1908), but the abstract style he
invented was original, and of great importance for the
future development of the modern movement.

94 ALEXANDER RODCHENKO *Construction of Distance* 1920

Tatlin and Malevich were not alone in their advance towards abstraction. Luckily they had established contacts – personal as well as literary – with the Futurist and Cubist movements in other countries before the war which broke out in August 1914 isolated them. It is more than likely that they had read Boccioni's 'Technical Manifesto of Futurist Sculpture' (see page 126 below). But isolation also meant consolidation. Filonov, Popova, Larionov, Goncharova, Udaltsova, Yakulov, Rodchenko, Puni, Exter, Menkov – all these artists carried out an intense creative activity during these war years in Moscow, and they were to be joined by other artists driven back to their native country

95 ALEXANDER RODCHENKO *Hanging Construction* 1920

by the war – notably Kandinsky, Pevsner and Gabo. Then in October 1917 came the Revolution, to intensify for a time all this revolutionary fervour in the arts. The artists themselves claimed that they had anticipated the revolution, had provided the basis of a revolutionary art. For a few years the politicians were too busy to interfere in such matters, but five years later they felt compelled to call a halt. The movement was suppressed, its promoters silenced or exiled, but they had already created, not merely a new movement in art, an advance in the evolution of style, but an altogether new kind of art, Constructivist art, and its practice was to spread from Moscow throughout the world.

We should note two or three decisive prototypes in this development, as expressed in the art of sculpture. One is 96 Tatlin's *Monument to the Third International*, commissioned early in 1919 by the Department of Fine Arts and exhibited in model form at the Exhibition of the VIII Congress of the Soviets in December 1920. It was designed to be twice the height of the Empire State Building in New York and to be executed in glass and iron.

> An iron spiral framework was to support a body consisting of a glass cylinder, a glass cone and a glass cube. This body was to be suspended on a dynamic asymmetrical axis, like a leaning Eiffel Tower, which would thus continue its spiral rhythm into space beyond. Such 'movement' was not to be confined to the static design. The body of the Monument itself was literally going to move. The cylinder was to revolve on its axis once a year, the activities allocated to this portion of the building were lectures, conferences and congress meetings. The cone was to complete a revolution once a month and to house executive activities. The topmost cube was to complete a full turn on its axis once a day and to be an information centre. . . . A special feature was to be an open-air screen, lit up by night, which would constantly relay the news. . . .[16]

Of course, such a project was never realized, and perhaps could never have been realized with the limited technical means available in Moscow at the time. But not only had a symbolic gesture been made – a gesture signifying that the modern artist was capable of creating new monuments to symbolize in appropriate materials the achievements of a new age; but further, a new type of art, relying on new materials like steel and glass, embodying dynamic instead of static principles, had been created, and given a social significance.

Naum Gabo conceived, but did not carry to the model stage, a similar project for a Radio Station, but his main

94

VLADIMIR TATLIN *Monument to the Third rnational* 1919–20

97 KASIMIR MALEVICH *Architectonics* 1924–8

researches were of a more intensive kind, and are represented by the *Constructed Head, no. 2* which he made in 1916. Gabo 98 had been in Munich and Paris and was familiar with the early stages of analytical Cubism and of the later development towards synthetic Cubism. His *Head* of 1916 may be contrasted with Picasso's *Head* of 1909–10. Picasso's head, as 54 I have already observed, has been conceived with a strictly naturalistic aim – to reinforce the 'realism' of the object by consolidating its form, by eliminating the uncertainties of chiaroscuro. Gabo's aim, like Tatlin's, is to create a spatial reality – the motif is an excuse for this creative intention, a point of departure. The head still gives us an illusion of the

98 NAUM GABO *Constructed Head, no. 2* 1916

original form of the motif, and is even expressive of a certain
feeling – melancholy or meditation. But what holds our
attention and overwhelms all other sensations is the dis-
position and interlocking of precisely defined planes, the
rhythmic organization of space. As a promoter of feeling
the humanity of the motif is irrelevant; we are asked to
assimilate an image of dynamic forces, and nothing more.

A similar intention is present in the constructions of
90, 92–5 Alexander Rodchenko, and those of Kasimir Medunetsky
and Lev Bruni, all made between 1917 and 1920.[17] Some of
these seem to have been crudely put together, and have none
of the exquisite refinement that was to characterize the later

96

99 ANTOINE PEVSNER *Portrait of Marcel Duchamp* 1926

works of Gabo and Pevsner. In general one might say that all the basic features of Constructivism were discovered and elaborated in these formative years, and all that remained for subsequent sculptors outside Russia in future years was to apply these principles and refine their applications.

The diffusion of the Constructivist 'idea' throughout Europe and America received its main impetus from the dispersal of the Russian artists from 1922 onwards. But we must remember that some of these artists had already established links with sympathetic groups in other countries. Although, as already suggested, one must not underestimate

100 ANTOINE PEVSNER *Head of a Woman*
(*Construction*) 1925

the infiltration of visual 'ideas' or images through the
circulation of printed magazines and photographs, it is
nevertheless certain that a 'will to abstraction' became
manifest more or less simultaneously in several countries,
and one can find reasons for this in the rising level of
anxiety and disillusion that preceded, accompanied and
followed the First World War. In retrospect the years before
that war seem calm and unperturbed; but this was not the
intellectual atmosphere of the period, which was full of
poets and philosophers prophesying doom (Nietzsche,
Ibsen, Dostoevsky, Strindberg, Spengler). By the early
years of the new century a lack of confidence in inevitable
progress, a feeling of spiritual uneasiness, had affected
sensitive artists everywhere, and a complacent reflection

98

ANTOINE PEVSNER *Torso (Construction)* 1924–6

of the world of nature no longer suited the mood of the intelligent public.

This reaction took the various forms we call Expressionism, Cubism, Futurism, Suprematism, etc., but of all these reactive tendencies the one that was most positive, and in a sense most optimistic, was that which sought to ally itself with engineering and other productive crafts – architecture, furniture manufacture, pottery, typography. But it soon became apparent – and this was most decisively demonstrated in Russia – that a new society in the making had no use for the engineer-artist, precisely because, in the stress of revolution or of economic crisis, he was useless, functionless. In Moscow Tatlin tried desperately to maintain the link, but his 'laboratory art', in so far as it was utilitarian, was industrial rather than artistic (he had, in any case,

102 NAUM GABO *Monument for a Physics Observatory* 1922

103 NAUM GABO *Column* 1923

104 NAUM GABO *Circular Relief* 1925

renounced 'aesthetics'). He designed workers' clothes, stoves, pottery and furniture, and affected to despise the painted canvas and functionless sculpture.

A practical activity of this kind was acceptable to the doctrinaire communists (who, however, more and more demanded that the artist should be a pictorial propagandist, a visual educator of the proletariat). But other artists in the group, notably Kandinsky, Gabo, Pevsner, Rodchenko and El Lissitzky, believed that the function of art was more indirect – that it was a research into basic elements of space, volume and colour, in order to discover, as they said, 'the aesthetic, physical and functional capacities of these materials'. Sculpture and constructions in relief seemed to offer the best means of demonstrating such physical and functional capacities, for the *eventual* benefit of production.

Their enterprise, in retrospect, seems courageous but, in the revolutionary situation, unrealistic; and so it proved. By 1921 or 1922 the position of these artists had become untenable. In 1922 a comprehensive exhibition of Russian art

was organized by the Van Diemen Gallery in Berlin, and several of the Constructivists from Moscow accompanied it, to mount the exhibits and to give demonstrations and lectures. Tatlin, Rodchenko and El Lissitzky took part in these activities, but afterwards returned to Moscow; Gabo, who also took part, decided to stay in Western Europe and eventually found his way to Paris.

During his stay in Berlin in 1922 El Lissitzky edited, with Ilya Ehrenburg, a Constructivist magazine of the arts with a title in three languages – *Vestich*, *Objet*, *Gegenstand*. The contributions were also in Russian, French and German and included work by Constructivist artists from all over Europe – Léger and Le Corbusier from France, Hans Richter from Germany, Moholy-Nagy from Hungary. A

105 LE CORBUSIER
Ozon, Op. 1 1947

106 GEORGES VANTONGERLOO *Sculpture Space: $y = ax^3 - bx^3$* 1935

107 LÁSZLÓ MOHOLY-NAGY *Plexiglass and chromium-rod Sculpture* 1946

Congress of Constructivists was held in this same year in Düsseldorf and henceforth Constructivism was a European movement. Its Constructivist character, in a practical sense, was confirmed by the gravitation of several of the Constructivist artists to the Bauhaus established by Walter Gropius at Weimar in 1919, with ideals almost identical with those of the Russian group. 'The complete building,' declared the first 'proclamation' of the new school, 'is the final aim of the arts. . . . Architects, painters and sculptors must recognize anew the composite character of a building as an entity. Only then will their work be imbued with the architectonic spirit which it has lost as "salon art". *Architects, sculptors, painters, we must all turn to the crafts.*'[18]

Theoretically and practically sculpture did not exist as a separate 'art' in the Bauhaus – the curriculum was divided into *Werklehre* and *Formlehre*, that is to say, instruction in materials and tools and instruction in observation, representation and composition. What emerged from this teaching

103

was a 'construction' and if such a construction was three-dimensional, it might bear some resemblance to a piece of sculpture in the conventional sense. But it would be called an 'exercise in static-dynamic relations', or simply a 'composition'.

This Constructivist approach to sculpture received further emphasis when, in 1922, Theo van Doesburg came from Holland to Weimar and organized a section of the 'Stijl' movement. This movement had been founded at Leyden in 1917 and included among its members Piet Mondrian, the painter, and J. J. Oud, the architect. Its ideals were by no means identical with the realistic or practical aims of the Bauhaus – indeed, van Doesburg boasted: 'I have radically turned everything upside down in Weimar. . . . Every evening I spoke to the pupils there and everywhere I scattered the poison of the new spirit.'[19] The new spirit was defined by van Doesburg as 'the development of modern art towards the abstract and universal idea, i.e. away from outwardness and individuality', towards 'a collective style which – beyond person and nation – expresses plastically the highest and deepest and most general desires of beauty of all nations'. As this ideal was to be realized by the de Stijl group, above all by Mondrian, it had less and less application to the 'craft' approach of the Bauhaus. The only sculptor produced by the de Stijl group, Georges Vantongerloo (b. 1886), was never very prolific and his work was to remain experimental, and well within Tatlin's ideal of 'laboratory art':

> It is SPACE that has always haunted me, even when my studies of the three dimensions still limited my vision. I didn't possess any other means of experience . . . space never ceased to occupy my thoughts. . . . Thus, in 1914 I made a Head of a Child. Without my wanting it, the child became my pretext for my study of space. I wasn't satisfied with that work. Why not? Well, it took me years to realize that the subject 'child' is nothing but a parasite

106

108 NAUM GABO *Construction in Space with crystalline centre* 1938

which by dominating space destroys the very nature of it.
No, the child failed as a means of expression, it failed as a
language in which to express Space. Seeing that the subject
'Nature' never provided me with anything more than a
limited experience, I abandoned both painting and sculpture.[20]

Equally within the concept of laboratory art was the work
of a much more prolific artist, László Moholy-Nagy (1895–
1946), who joined the Bauhaus in 1923 and for five years
conducted the preliminary course (in association with
Josef Albers). There was no limit to the ingenuity and
inventiveness of Moholy-Nagy, and he did much to develop

what he called 'a direct experience of space itself', the inter-
weaving of shapes 'ordered into certain well defined, if
invisible, space relationships; shapes which represent the
fluctuating play of *tensions* and forces'.[21] This led him
eventually to mobile sculpture, and since he wanted 'to
supersede pigment with light' he had to 'dissolve solid
volume into defined space'. He seized upon the new material
'plexiglass', but it was not until 1943 that he completed his
107 first plexiglass and chromium-rod sculpture. 'Two heavy
planes of perforated plexiglass were held together by
chromium rods; as the suspended form turned, it created a
virtual volume of reflected light or it merely vibrated as the
air around it moved.'[22]

Though a concern to represent space is a legitimate pur-
suit for an artist, it may be doubted whether this element
can be realized by concrete media that remain within any
logical definition of sculpture. If the art and the word that
signifies the art have any precise meaning, they indicate a
solid material that is carved (or, by a permissible extension
of meaning, moulded) to represent an integral mass *in* space,
i.e. occupying space. It is perfectly legitimate to create
volumes whose spatial confines have an expressive function,

109 NAUM GABO *Spheric Theme* 1937

110 NAUM GABO *Translucent Variation on Spheric Theme* 1951

and that is precisely the function of architecture, which is an art of hollows. The specifically plastic sensibility, as I have written elsewhere,[23] involves three factors: a sensational awareness of the tactile quality of surfaces; a sensational awareness of the volume or (to avoid this ambiguous word) the mass encompassed by an integrated series of plane surfaces; and an acceptable sensation of the ponderability or gravity of the mass, i.e. an agreement between the appearance and the weight of the mass. The 'language of space' invented by Vantongerloo and Moholy-Nagy satisfies none of these conditions. In his introduction to the catalogue of the Vantongerloo exhibition held in London in 1962, Max Bill states that Vantongerloo's 'point of departure was not to produce works of art but to present his ideas through colour and space' – a conceptual activity, therefore, not an aesthetic one. 'More and more,' we are told, 'Vantongerloo

111 NAUM GABO *Construction in Space* 1953

dissociates himself from the "making of works of art" and
to an ever-growing degree his works become idea patterns,
sketches of captured processes of nature.'

 As 'a characteristic expression of our age . . . in tune with
the experimental thinking of our time', Vantongerloo's
'ideas' are of great interest, but they have no sculptural
significance. This is also true of most of Moholy-Nagy's
experiments, and that is why these artists must finally be
dissociated not only from Piet Mondrian and the de Stijl

108

112 NAUM GABO *Arch no. 2* 1960

group, but also from Constructivists like Gabo and Pevsner.

At the conclusion of the Russian Exhibition of 1922, Gabo stayed in Berlin for a period of ten years, with occasional visits to other parts of Germany, to Holland and Paris. Pevsner, who had not gone to Berlin, left Moscow early in 1923 and first stayed with his brother in Berlin for nine months. It was during this period that he made his first construction. It is to be noted that Marcel Duchamp was also in Berlin at this time and may have had some contact with

100

Pevsner. In October Pevsner went to Paris, where he had lived before the war (in 1911 and again from 1913 to the outbreak of the war in 1914) and where he had already come into contact with the Cubist painters, and where, in 1913, he had seen Boccioni's exhibition of 'architectonic constructions'.

The relation between the work of the two brothers has been the subject of much controversy and misunderstanding. Pevsner and Gabo had spent the first years of the war in Norway, and it was there that together they worked out the basic principles of constructive form that were to survive the impact of Suprematism and 'laboratory art' through the five years of revolution in Moscow (1917–22). But from 1914 to 1923 Pevsner confined himself to painting, while Gabo during this decade concentrated on three-dimensional constructions. The first constructions of Pevsner repeat the early experiments of Gabo, and it was only gradually, and away from the influence of his brother, that Pevsner developed his individual style in sculpture.

In 1924 the two brothers held a joint exhibition at the Galerie Percier in Paris. Pevsner's work then, and even later, (the *Torso* of 1924–6 and the *Portrait of Marcel Duchamp*, 1926), shows little advance on Gabo's *Constructed Head, no. 2* of 1916, whereas in Gabo's *Monument for a Physics Observatory* of 1922, the *Column* of 1923, and *Circular Relief* of 1925 new materials like glass and plastic were for the first time used to express a new sense of space and dynamic rhythm, and also a sense of social relevance. 'The constructive principle leads into the domain of architecture,' Gabo had declared. 'Art formerly reproductive has become creative. It is now the spiritual source from which future architects will draw.' In addition to the project for a *Monument for a Physics Observatory* he designed a *Monument for an Airport* (1924–5) and a project for the Palace of the Soviets (1931) and was commissioned by the Berlin city architect, Hugo Häring, to design a *Fête lumière* for the Brandenburg Gate (1929). Two

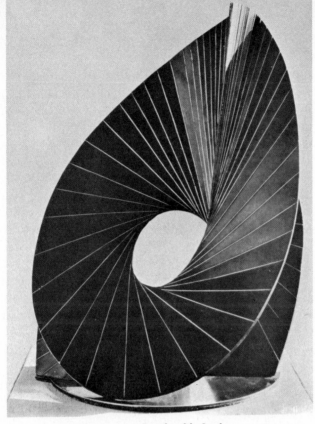

113 ANTOINE PEVSNER *Developable Surface* 1938

years earlier the two brothers had collaborated in the décor
for Diaghilev's ballet *La Chatte*, which was successfully pro-
duced in Monte Carlo, Paris, London and Berlin.

From 1932 Gabo was in Paris and took a leading part in
the direction of the group 'Abstraction-Création, art non-
figuratif'. This group was for a time extremely active, even
aggressive, and did much to establish the concept of a com-
pletely non-figurative kind of art. In a manifesto which the
two brothers issued on joining the group in Paris, partly a
translation of their 'Realistic' manifesto issued in Moscow
in 1920, they reaffirmed the 'fundamental bases of art'

111

(space and time) and denied volume as an expression of space. They also rejected physical mass as an element of plasticity and 'announced' that the elements of art have their basis in a *dynamic rhythm* (kinetic rhythms, the 1920 Manifesto explained, are the basic forms of our perception of *realtime*). This has remained the aim of an uncompromising Constructivist like Gabo – to create structures that are 'a vital image of space and time'.

Gabo remained in Paris until 1936, Pevsner until his death in 1962. From 1936 to 1946 Gabo lived in England, at first in London and after the outbreak of the war in Carbis Bay, Cornwall, where Ben Nicholson, Barbara Hepworth and several other artists had found a refuge. Since 1946 Gabo has lived in the United States, becoming a citizen in 1952.

The Constructivist idea in art has not changed since it was first formulated by Gabo – it is one of those irreducible concepts that do not change, and that even tend to a theoretical exclusion of the personal elements in style. But the artist cannot altogether escape from his personality, and in spite of the many manifestations of the Constructivist idea that have taken place in the past thirty years, the work of a Gabo or a Pevsner, a Mondrian or a Vantongerloo, remains personal and distinctive. One may note, especially, the divergencies of style that evolved as between Gabo and Pevsner once they had become separated. While never departing from the basic principles of Constructivism, Pevsner's carefully wrought constructions, usually made from solid metals rather than transparent plastics, gradually took on a 'painterly' (*malerisch*) surface quality that is quite distinct from the crystalline precision of Gabo's images. Both styles are therefore personal. Before the concepts of space and time can be embodied in a material construction they must pass through the mobile lens of a human sensibility, and in the process they take on distortions (i.e. stylistic modifications) that are inseparable from the human element that conceived them. Even scientists have had to admit the

114 ANTOINE PEVSNER *Column* 1952

presence of this human element in their carefully controlled empirical observations. For this reason the Constructivist has never been content to describe his work as 'abstract'.

'Abstract' is not the core of the Constructive Idea I profess [Gabo has said]. The idea means more to me. It involves the whole complex of human relation to life. It is a mode of thinking, acting, perceiving and living. . . . Any thing or action that enhances life, propels it and adds to it something in the direction of growth, expansion and development is Constructive.[24]

In his writings as well as in his works, Gabo has established certain standards for a constructive art which have had and continue to have a profound effect throughout the world. They combine with and support similar standards established by Mondrian for the art of painting and they have structural correspondences with the ideals and standards of modern architecture as established by Gropius, Mies van der Rohe, Aalto, Le Corbusier and others.

Must we conclude that Constructivist sculpture is a proto-typical or ideal form of architecture, with no aesthetic justification as a separate art? That is not the belief of Gabo, who assigns to constructive sculpture an entirely independent function, an ontological function. The mind or consciousness of man progresses, however slowly, by the conquest of reality, by which we mean the invention of new images to represent the nature of that reality, as present in the consciousness of the artist. In that sense, science and art are parallel activities, the one advancing from empirical observations to new and ever more comprehensive concepts or hypotheses about the nature of the physical world, the other advancing from intuitive apprehensions of the nature of the same physical world to new and ever more exact images to represent such intuitive apprehensions. The images of the artist are concrete – that is to say, material constructions that project the mental image as icons of universal significance.

From Futurism to Surrealism

'I am obsessed these days by sculpture! I think I can perceive a complete renewal of this mummified art' – so wrote Umberto Boccioni (1882–1916) in a letter from London to his friend Vico Baer dated 15 March 1912.[1] Boccioni's interest in sculpture had begun early in that year; he died as the result of an accident on 17 August 1916. In these four years he made a profound contribution to the renewal of the art, and fifty years later his influence still persists.

The general character of 'Futurism' is well known and has been described in *A Concise History of Modern Painting*. I shall confine myself to the application of its 'principles' made by Boccioni to the art of sculpture. It is important to stress the originality of the movement. Cubism, as we have seen, was a logical development from the position in painting reached by Cézanne. One can even interpret it as a form of classicism, and in their development the Cubist protagonists, Braque and Picasso, never made a decisive break with the figurative tradition – Cubism to them was another style for achieving the same ends as Ingres, Degas or Cézanne. The Futurists, by contrast, were not only the first artists specifically of a technological civilization: their principles were derived from technology – from power and movement, from mechanical rhythms and manufactured materials. In another letter to Vico Baer, this time from Paris (undated, but probably written in June 1913) Boccioni makes very clear his awareness of this distinction:

All cubism does not seem to be going ahead by a single step, painting moves little and is surely not on a path of a true revolution of sensitivity. Archipenko's sculpture

115 HENRI LAURENS *Composition in black and red sheet iron* 1914

has lapsed into the archaic and the barbaric. This is a mistaken solution. Our own primitivism should have nothing in common with that of antiquity. Our primitivism is the extreme climax of *complexity*, whereas the primitivism of antiquity is the babbling of *simplicity*.[2]

This statement serves to distinguish the Futurists from the Cubists and those sculptors influenced by Cubism such as Archipenko and Brancusi; it indicates that a 'true revolution of sensitivity' implies more than a change of style: more than a change of method or means. The whole ideological foundations of art as a human activity were to be changed, and corresponding to the new ideology there would be new images, new materials, new social functions. More than the plastic arts were involved – poetry, architecture,

116

UMBERTO BOCCIONI *Horse+Rider+House* 1914

drama and even, as a method of engaging all society in a transformation of sensibility, political action.

The machine came first, as the icon that inspired their ideas. The Futurists decided that the distinguishing characteristic of the machine was its self-sustained movement, its dynamism. Filippo Tommaso Marinetti, the leader of the group, declared in his first manifesto that 'the world's splendour has been enriched by a new beauty: the beauty of speed. . . . A racing motor-car, its frame adorned with great pipes, like snakes with explosive breath . . . a roaring motor-car, which looks as though running on shrapnel, is more beautiful than the *Victory of Samothrace*.'

This 'initial' manifesto, signed by Marinetti only, which was first published in *Le Figaro*, Paris, on 20 February 1909,

117

117 UMBERTO BOCCIONI
Unique Forms of Continuity in Space 1913

is full of sound and fury but contains little that deals speci-
fically with the arts – Marinetti himself was a poet:

We shall sing of the great crowds in the excitement of
labour, pleasure and rebellion; of the multi-coloured and
polyphonic surf of revolutions in modern capital cities;
of the nocturnal vibration of arsenals and workshops
beneath their violent electric moons; of the greedy
stations swallowing smoking snakes; of factories sus-
pended from the clouds by their strings of smoke; of
bridges leaping like gymnasts over the diabolical cutlery
of sunbathed rivers; of adventurous liners scanting the

118 UMBERTO BOCCIONI
Anti-Graceful (The Artist's Mother) 1912

horizon; of broad-chested locomotives prancing on the
rails, like huge steel horses bridled with long tubes; and
of the gliding flight of aeroplanes, the sound of whose
screw is like the flapping of flags and the applause of an
enthusiastic crowd.

And much more of this kind, breathless and incoherent. As
for art – 'art can be nought but violence, cruelty and in-
justice. . . . We wish to destroy the museums, the libraries,
to fight against moralism, feminism and all opportunistic
and utilitarian meanness.' There is a more sinister note,
prophesying fascism: 'We wish to glorify War – the only

119 RAYMOND DUCHAMP-VILLON *Horse* 1914

health giver of the world – militarism, patriotism, the destructive arm of the Anarchist, the beautiful Ideas that kill, the contempt for women.'

But when, about a year later (11 April 1910), the group that had gathered round Mussolini issued a second so-called 'technical' manifesto, there was less sound and fury, far more about aesthetics. The signatories (Boccioni, Carrà, Russolo, Balla and Severini) set about 'to expound *with precision*' their programme for 'the renovation of painting'.

We are only concerned for the present with this programme in so far as the general principles announced in it

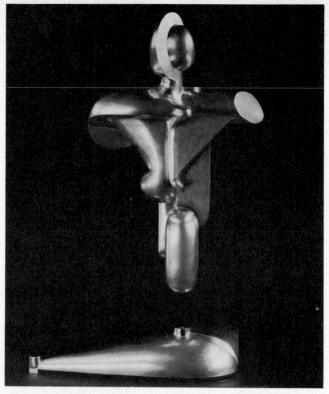

121 OSKAR SCHLEMMER *Abstrakte Rindplastik* 1921

apply to sculpture as well as to painting. There is really only one such principle:

> ... the gesture which we would reproduce in canvas shall no longer be a fixed *moment* in universal dynamism. It shall simply be the dynamic sensation itself made eternal. ... Space no longer exists. ... Who can still believe in the opacity of bodies, since our sharpened and multiplied sensitiveness has already penetrated the obscure manifestations of the medium? ... Our bodies penetrate the sofas upon which we sit, and the sofas penetrate our bodies. ... The harmony of the lines and folds of modern dress works upon our sensitiveness with the same emotional and symbolical power as did the nude upon the sensitiveness of the old masters. ... We fight against

the nude in painting, as nauseous and as tedious as adultery in literature.

The essential point in this manifesto (which also declared that 'the art critics are useless or harmful') is the insistence on dynamism as the typical sensation of our time and on the consequent duty of the artist to render this sensation in painting. Of the technical means to be employed there is no indication in the manifesto, but in the years that immediately followed (1910 to 1914) one method is common to all these painters – a divisionism that allows them to give an overall dynamic rhythm to the representation of the subject or 'motif'. Superficially their canvases may look like those of the Cubists – still more like those of the 'Orphist', Roger Delaunay. But there is a fundamental difference. In the analytical Cubism of Picasso and Braque, the definite purpose of the geometricization of the planes is to emphasize the formal structure of the motif represented. In the synthetic

122 DAVID HARE
Man with Drum 1948

123 GIACOMO BALLA *Boccioni's Fist—Lines of Force* 1915

Cubism of Juan Gris the definite purpose is to create an
effective formal pattern, geometricization being a means
to this end. In Delaunay's case it is a question of conveying
the radiant energy of light or perhaps the 'space that no
longer exists'. But the fragmentation that takes place in a
Futurist painting has quite another aim – to create linear

124 ALEXANDER ARCHIPENKO *Boxing Match* 1913

elements ('force–lines', as they were called) that can be 'serialized' to give the effect of movement (Boccioni's drawings of 'states of mind' are always the mental sensations conveyed by swirling lines). If these swirling elements nevertheless add up to a 'composition' with an overall formal structure, this is merely an arbitrary design imposed

on the painter by the two-dimensional area of the canvas. Formal coherence is of secondary importance.

When Boccioni turned to sculpture he sought to apply these same principles to the free-standing object. The 'Technical Manifesto' he issued on 11 April 1912, whatever its polemical aim, is in any case a profound analysis of the aesthetic principles of sculpture. Boccioni begins with a denunciation of the 'pitiable barbarism, clumsiness and monotonous imitation' of the sculpture of every country 'dominated by the blind and foolish imitation of formulas inherited from the past'. 'In all these manifestations of sculpture . . . the same error is perpetuated: the artist copies the nude and studies classical statuary with the simple-minded conviction that he can find a style corresponding to modern sensibility without relinquishing the traditional concept of sculptural form.' Boccioni has little difficulty in demonstrating the absurdity of such an aim, and then declares that 'there can be no renewal in art whatever if the essence itself is not renewed, that is, the vision and concept of line and masses that form the arabesque'. To renew the art of sculpture:

we have to start from the central nucleus of the object that we want to create, in order to discover the new laws, that is, the new forms, that link it invisibly but mathematically to the APPARENT PLASTIC INFINITE and to the INTERNAL PLASTIC INFINITE. The new plastic art will, then, be a translation into plaster, bronze, glass, wood, and any other material, of those atmospheric planes that link and intersect things.

Boccioni called this 'vision' PHYSICAL TRANSCENDENTALISM, a vague enough phrase, but he went on to define his meaning. Sculpture must give life to objects by a system of interpenetration. Objects do not exist in isolation – they cut through and divide the surrounding space in 'an arabesque of directional curves'. Only Medardo Rosso,

KURT SCHWITTERS *Merzbau* Begun 1920, destroyed 1943

among the sculptors of the past, had had any inkling of 'rendering plastically the influences of an ambience and the atmospheric ties that bind it to the subject'. Boccioni had a high regard for Rosso's revolutionary approach to sculpture, but felt that in the end 'the impressionistic necessities' had unduly limited his research 'to a kind of high or low relief, demonstrating that the human figure is still conceived of as a world in itself with traditional bases and an episodic goal'. Rosso, therefore, remained an Impressionist, his work fragmentary and accidental, lacking a synthesis.

Boccioni's 'synthesis' would be a 'systematization of the interpenetration of planes'. The foundation would be architectural, 'not only in the construction of the masses, but in such a way that the block of the sculpture will contain within itself the architectural elements of the SCULPTURAL ENVIRONMENT in which the subject lives'.

This might seem to be nothing more than a reversion to

126 KURT SCHWITTERS
Autumn Crocus 1926–8

127 KURT SCHWITTERS *Ugly Girl* *c.* 1943–5

the 'open form' and dynamism of Baroque sculpture, but this Boccioni fiercely denied, and it is perhaps easy to see the distinction. Apart from Boccioni's desire to 'abolish in sculpture as in every other art THE TRADITIONAL SUBLIMITY OF THE SUBJECT', there is a technical difference. The lines of force in a piece of Baroque sculpture (and especially so when part of an architectural complex) are self-sufficient, or, to use Boccioni's own word, 'episodic'. They turn in upon themselves, at best relating to an architectural complex. But the general aim of the Futurists was to achieve an interpenetration of the work of art and the environment, of form and atmosphere. 'WE BREAK OPEN THE FIGURE AND ENCLOSE IT IN ENVIRONMENT,' declared Boccioni with maximum emphasis. 'The sidewalk can jump up on your table and your

head be transported across the street, while your lamp spins a web of plaster rays between one house and another.'

To translate all these precepts into practice was not easy. The most literal attempt was a structure in various materials that has not survived (though a photograph exists) which shows the *Fusion of a Head and a Window*. The head in question is split open to admit a section of wood and glass from a window frame, and very solid rays of light stream down and over the head. The general effect, judging by the photograph, is very confused. This cannot be said of the three bronzes which are the permanent representatives of Boccioni's solution of 'the problem of dynamism in sculp- 118 ture' – the *Anti-Graceful* (*The Artist's Mother*) of 1912, the 120, 117 *Development of a Bottle in Space* of the same year, and *Unique*

128 *Mathematical Object. Kummer's plane surface with sixteen points, of which eight are true.* Photograph by MAN RAY

129 SOPHIE TAUEBER-ARP *Last Construction, no. 8* 1942

Forms of Continuity in Space (1913). Some drawings in the Winston Collection provide a clue to the sculptor's procedure. The head of a woman, for example, is reduced to a series of intersecting curves which may be intended to represent characteristic lines of facial expression – a smile, a grimace, a pout, etc. These are then translated into a model (of plaster or wax) and the result (in *Anti-Graceful*) is hardly to be distinguished, except in its ruggedness, from the frankly expressionistic (or impressionistic) work of Rosso. Dr Taylor, in his monograph on the artist,[3] describes the piece as:

> combining the heavy sculptural mass with freely moving surface planes . . . a lively image that seems to burst with inner life. It startlingly merges geometrical forms with

131

130 CONSTANTIN BRANCUSI *Bird in Space* 1919

ANTOINE PEVSNER *Projection into Space* 1924

soft fleshy shapes, yet is unified by the unflagging vitality
of the surface. Many of Boccioni's cherished ideas find
voice: the forms of far-away houses merge with the form
of the head; the face has an extraordinary range of ex-
pression, it smiles, frowns, or is pensive according to
the view and the viewer; and bold rhythms seem to
envelop the physical form.

Though, as Dr Taylor suggests, this work may be 'just one
long step removed from the freely modelled heads of Rosso',
it still does not constitute such a revolutionary advance
as the *Development of a Bottle in Space*. In certain respects 120
this highly original piece is an anticipation of Picasso's
Glass of Absinthe of 1914 in that the inner space of the 55
bottle is exposed and it becomes possible to suggest the
immateriality of the substance (glass) by means of the
dynamic rhythm of the open spiral form. Ingenious as this
solution is, it is exceeded by the skill with which Boccioni,
in his monumental *Unique Forms of Continuity in Space*, 117
succeeds in conveying the striding advance of a human

133

figure – one is tempted to add 'through space', but since we have been told that 'space no longer exists' the intention is presumably to suggest 'a bridge between the exterior plastic infinite and the interior plastic infinite'. That may be a rather meaningless phrase, but Boccioni had in mind the idea that 'objects never end', and 'intersect with in-finite combinations of sympathetic harmonies and clashing aversions'. The infinity is one of movement and not of space.

None of the other Futurists had the plastic sensibility and creative ambition of Boccioni, but Giacomo Balla (1871–1958) experimented with assemblies of various impermanent materials, presumably in the manner of the *Horse+Rider+House* of 1914 in the Peggy Guggenheim Collection, which is a delicate construction of wood, cardboard and metal. Balla's works of this kind seem to have perished, with the exception of the structure in cardboard and wood (painted red) in the Winston Collection, *Boccioni's Fist – Lines of Force* (1915). This piece bears a certain resemblance to Archipenko's *Boxing Match* (1913) and there are other parallels to be drawn between the sculpture of Boccioni and Balla and the contemporary sculpture of Archipenko, Duchamp-Villon and Henri Laurens. I think there can be no question of the priority of the Futurists: their concept of a dynamic sculpture had been formed as early as 1910, at a time when the Paris sculptors were still working out the implications of the quite different principles of Cubism. Laurens's *Composition in black and red sheet iron* of 1914 (Collection Maurice Raynal) is a tribute to Boccioni's *Horse+Rider+House* (dated 1912–13 by one authority, 1914 by another);[4] and Duchamp-Villon's series of *Horses* (1914), if not directly related to Boccioni's *Development of a Bottle in Space*, is inspired by the same principle of dynamics.

The connecting link between Futurism and Cubism, between Paris and Milan, was the painter Gino Severini (b. 1883). He had settled in Paris in 1906 but nevertheless he kept in close touch with his friends Balla and Boccioni, with

116

123

124

115

119
120

134

132 JEAN ARP *Madame Torso with wavy Hat* 1916

whom he had worked in Rome from 1900 onwards (Balla
had spent seven months in Paris that year, and returned to
Rome as an apostle of Seurat). In spite of his Parisian
domicile, Severini signed the Futurist manifestoes of 1910
and 1912, but apparently with some mental reservations.
Severini had summoned his friends (Boccioni and Carrà) to
Paris in the autumn of 1911, to confront them with the
Cubists' achievements. Boccioni was impressed, but the
final effect was to clarify his own methods rather than change
any principles. There could be no compromise between an
art that sought to realize movement and 'states of mind',
and one (like Cubism) that sought to establish the position

133 JEAN ARP *Forest* 1916

of objects in space. There is a clear realization of this fact
in Daniel-Henry Kahnweiler's book, *The Rise of Cubism*,
written in 1915 but not published until 1920. Kahnweiler,
the intimate friend of Picasso and Braque, was in a good
position to observe the conflict between Cubism and
Futurism. He suggests that many artists were using the
Cubist language of forms for aims other than those of the

134 MAX ERNST *Fruit of a long Experience* 1919

founders of the movement, and in particular refers to the
Futurists (with whom, it is interesting to note, he associated
Marcel Duchamp):

Even before the Futurists went over to Cubism, while
they were still using Divisionist technique, the subject
of all their manifestoes was dynamism, the endeavour to
represent movement in painting and sculpture. The idea

135　MARCEL DUCHAMP
In advance of a broken arm
1915

has not been abandoned since that time, for a book by Boccioni, one of the school, which was published in 1913, contrasted 'static' Cubism with 'dynamic' Futurism.

The Futurists tried to represent movement by depicting the moved part of the body several times in various positions, by reproducing two or more phases of movement of the entire figure, or by lengthening or widening the represented object in the direction of the movement. Can the impression of a moving form be awakened in the spectator in this way?

It cannot. All these solutions suffer from the same mistake which renders that impression possible. In order to produce 'movement', at least two visual images must

136 PAUL NASH
Found object interpreted
(*Vegetable Kingdom*)
c. 1935

exist as succeeding points in time. In Futurism, however, the various phases exist simultaneously in the painting. They will always be felt as different, static, single figures, but never as a moving image. This is borne out by fact, as observation of paintings by Carrà, Severini or Boccioni will show.[5]

A Futurist might have answered (and probably did) that it is not necessary to present *objects* (paintings or sculpture) separately in order that two visual images may exist as succeeding points in time; the eye is capable of detaching such separate images from the area of the canvas or the mass of the sculpture: there are successive moments in the one visual event. But Kahnweiler's criticism does serve to show

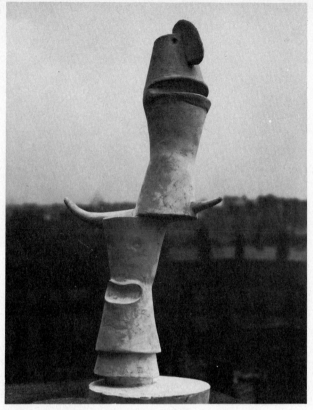

137 MAX ERNST *Tête double: Oedipus* 1935

the decisive nature of the difference between the aims of the Cubists and the Futurists. It is a difference that has persisted beyond the period of Cubism and Futurism – it is fundamentally a difference between a perceptual and a conceptual approach to art. Apollinaire tried to evade the distinction by establishing a category which he called 'instinctive cubism', in which he included the Futurists. The meaninglessness of the term is shown by his inclusion within the category of artists as diverse as Matisse, Rouault, Dufy, Severini and Boccioni.

The principle of dynamism in sculpture first established by the Futurists was to persist down to the present day. We

140

138 VICTOR BRAUNER *Signe* 1963

have already seen how it passed to Moscow at least as early
as 1913; Marcel Duchamp developed it in paintings like
his *Nude Descending a Staircase*, one of the most influential
works in the history of the modern movement. Even works
like Brancusi's *Bird in Space* ('a design which should expand 130
to fill the vault of heaven') or Pevsner's *Projection into* 131
Space (1924), have aims which correspond to those of the
Futurist sculptors. In short, the Futurists in their mani-
festoes gave to art, and to sculpture in particular, an ideal
of dynamism, of environment and atmosphere, of inter-
penetration and 'physical transcendentalism' which has
persisted for half a century and still inspires many artists.

I have already attempted, in *A Concise History of Modern Painting*, to trace the confused paths that led from Futurism to Dada and Surrealism. The confusion was deliberate – a systematic 'dérèglement' of the senses which had as its objective the release of the mechanisms that normally subdue the imagination in the interests of rational order and social conformity. The work of art, it was argued, aspired to or proceeded from a realm of indeterminacy, of chance, of dream which might have significance for life, but was superior to it – a realm of super-reality. In this general sense super-realism is the characteristic of this whole phase of modernism, and may be regarded as an extreme development of romanticism. The Surrealists were not formal or even technical innovators, as were the Cubists and Constructivists. They were very conscious of the past and found precursors in Blake and Baudelaire, Novalis and Nietzsche, Rimbaud and Lewis Carroll. The Dadaists, however, disdained the past as well as the present: they were in the strictest sense nihilists, and among the conventions they wished to destroy were the categories established for the arts

139 ALBERTO GIACOMETTI *Figure* 1928

140 ALBERTO GIACOMETTI *Man* 1929

by the academies of the past – categories like painting and sculpture, restrictions to materials like canvas, oil-paint, marble. To quote a passage from *A Concise History of Modern Painting*:

> . . . from the beginning Dada, inheriting the rhetorical propaganda of Marinetti, had claimed to be 'activist', and this in effect meant an attempt to shake off the

141 ALBERTO GIACOMETTI *Reclining Woman* 1929

142 ALBERTO GIACOMETTI *The Palace at 4 a.m.* 1932-3

143 MAX ERNST *The Table is Set* 1944

dead-weight of all ancient traditions, social and artistic, rather than a positive attempt to create a new style in art. In the background was wide social unrest, war fever, war itself, and then the Russian Revolution. Anarchists rather than socialists, proto-fascists in some cases, the Dadaists adopted Bakunin's slogan: destruction is also creation! They were out to shock the bourgeoisie (whom they held responsible for the war) and they were ready to use any means within the scope of a macabre imagination – to make pictures out of rubbish (Schwitters' *Merzbilder*) or to exalt scandalous objects like bottle-racks or urinals to the dignity of art-objects. Duchamp provided Mona Lisa with a moustache and Picabia painted absurd machines that had no function except to mock science and efficiency. Some of these gestures may now seem trivial, but that is to forget the task that had to be done – the breaking-up of all conventional notions of art in order to emancipate completely the visual imagination. Cubism had achieved much, but once it had rejected the laws of perspectival vision, it threatened to rest there and revert to a formal

144 MAX ERNST *Moon Mad* 1944

classicism more severe and rigid than the realism it had
escaped. Dada was the final act of liberation, and apart
from the response it elicited from Picasso and Braque,
and even Léger, it provided 'a lasting slingshot' for a new
and not less important generation of artists.[6]

Very significant for the future development of sculpture was
the obliteration of any formal distinction between the
painting, the relief, the sculpture-in-the-round and the
ready-made object. Indeed, certain works of the Dadaists
may be classified indifferently as paintings or sculpture, and
to separate them for the sake of a tidy history of either
category is to destroy their historical significance. Just as a

145 MAX ERNST *The King playing with the Queen* 1944

'*merzbild*' of Schwitters is no longer a painting, so a painted-wood relief by Arp is no longer either sculpture or painting. It is an *objet d'art*, but in a sense not always implied by that phrase; it is an object without qualifications. It could be, as Marcel Duchamp was to perceive, *ready-made* – that is to say, an ordinary object invested with significance by being removed from its normal environment or position, simply, for example, by being *turned upside down*.

The history of this phase of modern sculpture can best be related by annotating a paragraph written by Arp himself:

In 1914 Marcel Duchamp, Francis Picabia, and Man Ray, then in New York, had created a dada (hobby-horse) that

146 ALBERTO GIACOMETTI *City Square* 1948–9

left nothing to be desired. But great was their distress, for they found no name for it. And because it was nameless, we in Zurich knew nothing of its existence. But when in 1916 we engendered our Dada and it was born, we – Hugo Ball, Tristan Tzara, Richard Huelsenbeck, Emmy Hennings, Marcel Janco, and I – fell rejoicing into each other's arms and cried out in unison: 'Da, da ist ja unser Dada' ('There, there's our Dada'). Dada was against the mechanization of the world. Our African evenings were simply a protest against the rationalization of man. My gouaches, reliefs, plastics were an attempt to teach man what he had forgotten – to dream with his eyes open. Even then I had a foreboding that men would devote themselves more and more furiously to the destruction of the earth. The choicest fruits on the tree of Dada, gems

147 ALBERTO GIACOMETTI
Man pointing 1947

from top to toe, were those raised by my friend Max
Ernst and myself in Cologne. A little later we moved to
the Tyrol and Tristan Tzara joined us in the good work.
In Cologne Max Ernst and I founded the great enterprise
of 'Fatagaga' under the patronage of the charming
Baroness Armanda von Duldgedalzen and the well-to-do
Herr Baargeld (Mr Cashmoney). Overcome by an irresist-
ible longing for snakes, I created a project for reformed
rattlesnakes, beside which the insufferable rattlesnake of
the firm of Laocoön and Sons is a mere worm. At the very
same moment Max Ernst created 'Fata'. My reformed
rattlesnake firm and Max Ernst's Fata firm were merged

149

under the name of Fatagaga, and can be brought back to life at any time on request. The important thing about Dada, it seems to me, is that the Dadaists despised what is commonly regarded as art, but put the whole universe on the lofty throne of art. We declared that everything that comes into being or is made by man is art. Art can be evil, boring, wild, sweet, dangerous, euphonious, ugly, or a feast to the eyes. The whole earth is art. To draw well is art. Rastelli was a wonderful artist. The nightingale is a great artist. Michelangelo's Moses: Bravo! But at the sight of an inspired snow man, the Dadaists also cried bravo.[7]

The points to emphasize in this statement are:

1. '*Dada was against the mechanization of the world*. . . . My gouaches, reliefs, plastics were an attempt to teach man what he had forgotten – to dream with his eyes open' – this anti-rationalism is the emotional force behind the movement, and it was to be intensified by the prevailing wartime atmosphere – for modern war is essentially a war of machines, and victory goes to the side that invents the swiftest or most powerful machines. In protesting against the mechanization of the world, the Dadaists were protesting against war.

2. '*The choicest fruits on the tree of Dada . . . were those raised by my friend Max Ernst and myself in Cologne*' – the Dada movement was essentially Germanic in its origins. 'My old love for the German Romantics,' Arp says in this same article, 'is still with me.' He mentions Novalis, Brentano and Arnim – and 'the most beautiful thing of all . . . the interior of the Strasbourg cathedral with its great jewels, the miracle of its stained-glass windows. I will write a thousand and one poems about those windows.' But this romanticism, in 1914, had turned to self-mockery, to masochism and destructiveness. This is not the place to give a psychological explanation of the process, but Arp in his statement says

148 ALBERTO
GIACOMETTI
Monumental Head
1960

that 'even then I had a foreboding that men would devote
themselves more and more furiously to the destruction of
the earth' and his 'reformed rattlesnake firm' was a contribu-
tion to that end. To identify the Dada movement with the
furor teutonicus is perhaps misleading, in that its political
alignment was pacifist and anti-nationalistic. But it is always
possible to ride the local storm on a broomstick or a wild
ass.

Germany [as Jung has said] is a land of spiritual catas-
trophes where certain facts of nature never make more
than a pretence of peace with the world-ruler reason. The
disturber is a wind that blows into Europe from limitless
and primeval Asia, sweeping in on a wide front, from

149 JEAN ARP *Star* 1939–60

150 BERNHARD HEILIGER
Vegetative Sculpture, no. 1 1955

Thrace to the Baltic. Sometimes it blows from without
and scatters the nations before it like dry leaves, and
sometimes it works from within and inspires ideas that
shake the foundations of the world. It is an elemental
Dionysus that breaks into the Apollonian world.[8]

The rattlesnake of Dionysus can turn against the 'insuffer-
able rattlesnake of the firm of Laocoön and Sons'.

3. 'The important thing about Dada, it seems to me, is
that *the Dadaists despised what is commonly regarded as art . . .
we declared that everything that comes into being or is made by man
is art.* Art can be evil, boring, wild, sweet, dangerous,
euphonious, ugly, or a feast to the eyes.' In other words,

152

Dada represented a complete liberation of the creative impulse, and it was therefore able to embrace the most astonishing contradictions – above all the contradiction that, in spite of their destructive intentions, the Dada artists returned to certain essentials of art, and their art – the sculptures of Arp, the collages of Schwitters, the paintings of Max Ernst – has proved as enduring as any art of the twentieth century. 'I tried to be natural,' writes Arp. In that attempt lies the revolutionary significance of Dada, for to be natural is by no means the same as to be 'faithful to nature'.

Dada, in any coherence, did not survive the end of the First World War, but in that short period Arp had produced some works of great significance for the future of sculpture, notably certain painted-wood reliefs (such as *Madame Torso* 132 *with wavy Hat*, 1916 and *Forest*, 1916). After the war groups 133 were formed in Berlin, Cologne, Hanover (which again emphasize the Germanic character of the movement), with smaller offshoots in Basle and Barcelona. Arp went to join the new group in Cologne, and there rejoined Max Ernst, whom he had first met in 1914. Arp has in his possession a

JEAN ARP *Siamois* 1960

wooden figure of *Lovers* carved by Max Ernst in 1913, and

the painted relief of 1919 (*Fruit of a long Experience*, Collection Roland Penrose) may still be regarded as Dada sculpture. This latter piece is near to the painted reliefs made by Kurt Schwitters about the same time, such as the *Merz Construction* of 1919 which has not survived.[9] The 'method' of all these sculptures is to assemble 'found-objects' into meaningful relationship, to create a kind of plastic metaphor which has the same evocative power as a metaphor in poetry. But this method is also the method of Surrealist sculpture, so in this sense there is a complete continuity between Dada and Surrealism.

What might be called the apotheosis of the ready-made object is, however, a joke peculiar to Dada, and perhaps to be attributed to Marcel Duchamp alone. The idea seems to have arisen in the course of utilizing the shadows cast by ready-made objects as elements in a design. Robert Lebel, in his study of Duchamp,[10] quotes a note from Duchamp's *Green Box*, a portfolio of photographs, drawing and manuscript notes published in Paris in 1934:

> Shadows cast by ready-mades. Shadows cast by 2, 3, 4, ready-mades *brought together*. Perhaps use an enlargement of that so as to derive from it a figure formed by an equal /length/ (for example) taken in each ready-made and becoming by the projection a part of the cast shadow. . . . Take these 'becomings' and from them make a tracing without naturally changing their position in relation to each other in the original projection.

The ready-mades of Duchamp begin with the *Bicycle Wheel* of 1913 and it is important to understand the artist's

intention in choosing and exhibiting a ready-made object. That intention is in no sense aesthetic, as is the later intention of the Surrealists in presenting (and even mounting

or framing) an *objet trouvé*; much less any intention of using ready-made materials, as we have seen the Cubists did, for

their inherent decorative or plastic qualities. As Robert Lebel so acutely observes, Duchamp's intention was

to cut short any counter-attack of taste. He did not select a bicycle wheel as a beautiful modern object, as a Futurist might; he chose it just because it was *commonplace*. It was nothing but a wheel, like a hundred thousand others, and in fact if it were lost it could soon be replaced by identical 'replicas'. For the moment, resting upside down on a kitchen stool as a pedestal, it enjoyed an unexpected and derisive prestige which depended entirely upon the act of choosing by which it was selected. It was a kind of sacralization.

But is any act of choosing entirely arbitrary? Can any personal action be described as 'entirely arbitrary'? The objects chosen by Duchamp – a wheel, a bottle-rack, a urinal (upside down), a snow-shovel, a comb, a hat-rack suspended from the ceiling, etc., may conceivably have some unconscious association for the artist; and if not the object itself, its configuration or *Gestalt* may have some hidden significance. 'His is the whimsical mood of a spoiled child taking his revenge on the arbitrary decisions of adult logic,' declares Mr Lebel.[11] But one has a suspicion that the objects may be taking their revenge on the artist. 'He has never come so close to magic as in these veritable fetishes, which he has invested with a power which is evidently real, for since their consecration they have never ceased to inspire a devoted cult' – Mr Lebel again. But to replace the aesthetic cult by a magical cult does not seem to be the kind of liberation the Dadaists were seeking, and I doubt if Duchamp, who compared his ready-made to a 'sort of rendezvous', had any such pretensions. To import the notion of magic contradicts the only distinction that I believe can be made between Dadaism and Surrealism.

In June 1915, Duchamp decided to leave Paris and went to the United States, where his fame had preceded him. The

decision was no doubt forced on him by the wartime atmosphere in Paris (Duchamp had .been exempt from military service, but that was not a comfortable situation for a young man). It may also have been prompted by a feeling that he had nothing in common with the aesthetes of Paris, and wanted an unspoilt and naïve public for his audience. Duchamp was to be claimed by the Surrealists but, as Robert Lebel has perhaps been the only critic to appreciate, he has remained one of the few authentic Dada artists, and as such he has had his unique influence, especially in America. There is little in the prolific development of modern sculpture in the United States that cannot be attributed directly to the example of Duchamp. This is not to deny that he played an important role in the development of the Surrealist movement in Paris, but it was in the spirit with which he worked as a librarian when very young – 'I was always glad to supply any information I could to anyone who asked me politely.'[12]

If there is some doubt about the intention of Duchamp to invest his 'ready-mades' with magic, there is no doubt that the somewhat similar 'found-object' (*objet trouvé*) of the Surrealists was selected for its supposed magical quality. 'Magic' is an ambiguous word; what it usually means here is strangeness or fantasy, or what André Breton has called 'objective humour' – 'a synthesis in the Hegelian sense of the imitation of nature in its accidental forms on the one hand and of humour on the other'.[13] Breton himself illustrated such a synthesis in his *Poème-objet* of 1935, which is an assemblage, mounted on a board, of a dummy egg, a broken piece of mirror-glass, and the wings of a bird or angel presumably detached from some toy. It is a long way from the sculptural integrity of a Rodin or a Matisse, and to be just to the Surrealists we should remember that, like the Dadaists, they had no respect for formal categories – therefore they spoke of 'objects' and .not of 'sculpture'. Rather different, however, were the intentions of Alberto

JOAN MIRÓ *Man and Woman* 1956–61

Giacometti (b. 1901), who from the beginning was obsessed by the specifically sculptural theme of spatial relationships. At the time of the construction of his most Surrealist work, 142 *The Palace at 4 a.m.* (1932–3, now in the Museum of Modern Art, New York), he wrote:

> I whirl in the void. In broad daylight I contemplate space and the stars which traverse the liquid silver around me. . . . Again and again I am captivated by constructions which delight me, and which live in their surreality – a beautiful palace, the tiled floor, black, white, red under my feet, the clustered columns, the smiling ceiling of air, and the precise mechanisms which are of no use.[14] [And further] Once the object is constructed, I tend to see in it, transformed and displaced, facts which have profoundly moved me, often without my realizing it; forms which I feel quite close to me, yet often without being able to identify them, which makes them all the more disturbing.[15]

In these two statements the whole purpose and effect of a Surrealist sculpture is expressed – the construction in space of precise mechanisms that are of no use but are nevertheless

153 JOAN MIRÓ *Bird* 1944–6

154 JOAN MIRÓ
Figurine 1956

profoundly disturbing. The constructions were to become
at a later date (from 1940 onwards) human figures, some-
times disposed as a group like figures in a street or a square, 146
each intent on his own purpose and direction but constitut-
ing, in the totality of their movements, a spatial texture.
Giacometti still called these human groups 'constructions' –
'I have never regarded my figures as a compact mass, but as
transparent constructions' – and the persistent effect of
surreality in his work is due to this fact. Attempts have been
made to claim Giacometti for realism in art, or even for
humanism, but the human body has for him only the
significance of being the outward symbol of an intangible
subjectivity. A mournful sense of inner emptiness, which
cannot in any physical sense be 'filled', may perhaps be

redeemed by some solid symbol. But the symbol must not be too solid or precise, for the emptiness has no precise contours – hence plaster is his preferred medium. 'Pétrissant le plâtre, il crée le vide *à partir de plein*,' as Sartre has said.[16] 'Kneading the plaster, out of fullness he creates emptiness.'

Giacometti takes us beyond the immediate subject of Surrealist sculpture, but that was always the ambiguity, and one might say the deeper significance of a movement that claimed the greatest possible spiritual liberty. No limits can be set to human imagination – that was the specific claim of Breton's Manifesto (1924); but if there are no limits, there are no confining rules, which fact always made it difficult to establish in any coherent sense a Surrealist *movement*. Strictly speaking, there was never more than one Surrealist, the one who wrote the manifestoes. Admiration and affection (or a natural desire to participate in such brilliantly organized publicity) brought many adherents to the various manifestations that took place between 1924 and 1936, but they were all paying tribute, perhaps first to the poet and animator of the movement, but more significantly to 'le seul mot de liberté'. Certainly one must interpret Giacometti's Surrealism in this sense.

The case of Max Ernst is a little different. As a sculptor, as we have seen, he began with Dada and his motives were as destructive as those of the rest of the group. But like Arp and Schwitters, he too was to be seduced by beauty. 'The nightingale is a great artist.' In a letter to Carola Giedion-Welcker of 1935 Ernst relates:

Alberto Giacometti and I are afflicted with sculpture-fever. We work on granite blocks, large and small, from the moraine of the Forno Glacier. Wonderfully polished by time, frost and weather, they are in themselves fantastically beautiful. . . . Why not, therefore, leave the spadework to the elements and confine ourselves to scratching on them the runes of our own mystery.[17]

155 JOAN MIRÓ *Head* 1961

Some of the blocks thus scratched *in situ* at Maloja are now in private collections in New York and London. Similar stones were worked on when Ernst lived in Arizona (1946–9). In 1938 he occupied a house at Saint-Martin d'Ardèche, about fifty kilometres north of Avignon, and while there covered the walls with gigantic sculptural reliefs. But the more characteristic sculpture of Max Ernst, original in form and fantastic in conception, belongs for the most part to the summer of 1944, when he had a house at Great River, Long Island.

This series of modelled compositions (subsequently cast in bronze) shows Ernst's mastery of a technique he has only sporadically practised, and without any loss carries over into sculpture the wit and fantasy of his paintings. There are exceptional pieces like *The Table is Set* (1944) which seem to have some spatial significance reminiscent of Giacometti's wooden *Model for a Square* (1930–1), but most of them are 143

figurative in intention, it being understood that the figures are not of this world. Their features (*An Anxious Friend* and *Moon Mad*, 1944) are a throwback to the bronze *Lady Bird* of 1934–5, but the most successful piece is *The King playing with the Queen* (1944), which has a purely adventitious resemblance to Henry Moore's *King and Queen* of 1952–3. Max Ernst's sculptures remain in the realm of the 'elemental Dionysus': their spirit is uncanny rather than in any sense spiritual. The 'other' world into which they plunge us is not super-real, but infra-real, Plutonic rather than Olympian.

144
145
172

Other artists associated with the Surrealist movement made a decisive contribution to the development of modern sculpture, but it was mostly outside the period of the group's coherent activity. Joan Miró, for example, made a series of 'constructions' in 1929, but these are reliefs and more allied to painting than to sculpture. More recently he has experimented in ceramics, and some of his clay figurines have been cast in bronze (e.g. the *Bird* of 1944–6, the *Woman* of 1950 and the *Figurines* of 1956). Alexander Calder is often claimed as a Surrealist sculptor, but his characteristic mobiles, although they belong to the realm of fantasy, do not conform to Breton's definition of Surrealism as 'pure psychic automatism'. Rather they belong to the realm of play; they are products of that 'play instinct' which Schiller identified with the essential freedom, and essential humanity, of the work of art.

153
154
67

Impossible to separate from the typical manifestations of Surrealism are the works of the two dominating artists of our period – Picasso and Henry Moore. But it has never been possible to confine Picasso and Moore within the limits of a particular group or movement: their geniuses are universal and the manifestations of that genius in each case multifarious. Indeed, to approach an understanding of their great contribution to the art of sculpture we must consider them under a new rubric, that of *vitalism*.

The Vital Image

I have already (Chapter Three, page 77) referred to that development of modern sculpture which is best designated by the word *vitalism*. Like most new developments in modern art it was first inspired by Picasso, but this particular phase of sculpture has been dominated by the genius of Henry Moore, and an often-quoted statement of his justifies the use of the word vitalism in this connection:

Vitality and power of expression. For me a work must first have a vitality of its own. I do not mean a reflection of the vitality of life, of movement, physical action, frisking, dancing figures and so on, but that a work can have in it a pent-up energy, an intense life of its own, independent of the object it may represent. When a work has this powerful vitality we do not connect the word Beauty with it.

Beauty, in the later Greek or Renaissance sense, is not the aim of my sculpture.

Between beauty of expression and power of expression there is a difference of function. The first aims at pleasing the senses, the second has a spiritual vitality which for me is more moving and goes deeper than the senses.

Because a work does not aim at reproducing natural appearances it is not, therefore, an escape from life – but may be a penetration into reality . . . an expression of the significance of life, a stimulation to greater effort in living.[1]

This statement was contributed to a volume of manifestoes by British painters, sculptors and architects which I edited in 1934. Moore was already thirty-six years old, but his

163

156 HENRY MOORE *Internal and External Forms* 1953-4

157 HENRY MOORE *Standing Figure (Knife-Edge)* 1961

158 JACOB EPSTEIN *Rock Drill* 1913

159 JACOB EPSTEIN
Jacob and the Angel 1940

development had been forcibly delayed by the First World War and he had devoted only about ten continuous years to his craft, and these much interrupted by the necessity of teaching. The force and coherence of his ideal is already quite astonishing.

In the first stages of his development there are traces of the influence of Jacob Epstein, at that time a dominating and controversial figure in English art. Moore has also acknowledged his early debt to Anglo-Saxon sculpture, and as in the lives of most artists there is a preliminary phase of assimilation and rejection of prevailing styles. But influences are not always direct or precise, and a painter may be influenced by sculpture or a sculptor by painting. It is perhaps not necessary to observe further that art is a highly

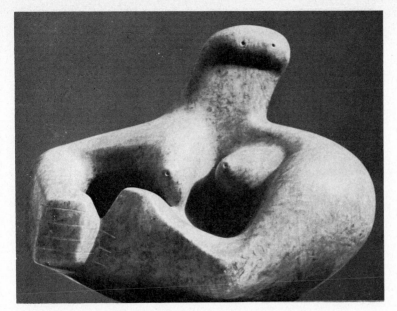

160 HENRY MOORE *Composition* 1931

contagious 'disease' – that the eye of the artist feeds un-
consciously on whatever formal motes come its way. To
strive to be uninfluenced by the work of one's predecessors
or contemporaries is neither possible nor desirable, all
questions of traditionalism apart. Artists confront their
destiny – the general history of the civilization of which they

HENRY MOORE *Reclining Mother and Child* 1960–1

162 PABLO PICASSO *Bathing Woman. Design for a Monument (Drawing)* 1927

are a part – with a certain unity. They react to this common destiny with a certain uniformity – we do not need a theory of dialectical materialism to explain such an obvious fact. But within this general historical process there are complex variations that arise fundamentally from differences in individual psychology, from difficulties of communication, from physical variations of all kinds. To distinguish between general influences and personal indebtedness in any particular case is almost impossible. Some attempt must, however, be made to assess Moore's debt to Picasso.

Before 1927 the few pieces of sculpture made by Picasso (such as the *Head of a Woman* of 1909–10) might be described as 'translations' – a motif from a painting is detached

54

PABLO PICASSO *Design for a Monument* 1929 164 HENRY MOORE *Composition* 1931

165 HENRY MOORE *Reclining Figure* 1945–6

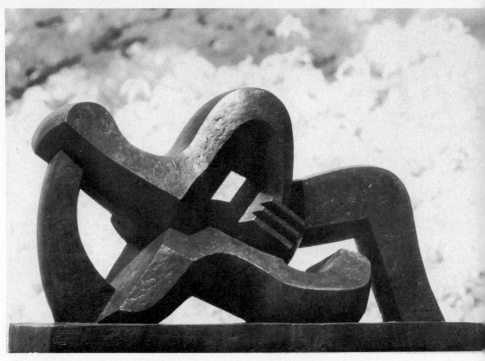

166 JACQUES LIPCHITZ *Reclining Nude with Guitar* 1928

and given independent, solid existence. It may have sculptural qualities, but the original image was pictorial. In 1927 Picasso began to conceive independent sculptural images, at first on canvas or as drawings, and then as three-dimensional forms. The distinction is perhaps subtle, but it is significant. Even in the preliminary drawings Picasso was, so to speak, feeling round the object depicted. The *Design for a Monument* which he modelled at Dinard on 28 July 1928 is a decisive innovation in the history of modern sculpture, though it is possible, as Alfred Barr notes, that it was influenced by the early paintings of Tanguy and the metamorphic figure paintings of his friend Miró.[2]

As I have already noted, Picasso began to concentrate on sculpture in 1931, in the newly acquired Château de Boisgeloup. A photograph by A. E. Gallatin, taken in

162
163

HENRY MOORE *Reclining Figure* 1929

1933, shows a studio full of plaster models, most of which were subsequently cast in bronze. They vary from the head of a woman of almost classical sweetness and serenity to serpentine contortions of the same head, and figures of animals (a *Cock* and a *Heifer*) which are distorted only to the degree necessary to give expressive emphasis.

There are a few figures by Henry Moore which may, perhaps, be directly related to Picasso's *Design for a Monument* – for example, the *Composition* in blue Hornton stone of 1931. But in general Moore's development, though related by a common purpose, was independent of Picasso's. Precisely the year of the *Design for a Monument* (1928) was the year in which Moore was overwhelmed by the Mexican sculpture in the British Museum, and this source of inspiration, with minor contributions from African sculpture,

164

171

168 HENRY MOORE *Time-Life Screen* 1952

169 HENRY MOORE
Helmet Head, no. 2 1

Romanesque sculpture, Brancusi and Archipenko, was decisive. Picasso may have continued to influence Moore, by his paintings rather than his sculpture, but from 1929 (the date of the first *Reclining Figure* now in the Leeds City Art Gallery) Moore was strong enough to pursue his own course, the course described in his Statement of 1934.

We should perhaps look at Moore's development from two aspects – the technical and the stylistic. Moore began with a strong preference for direct carving – practically all his work, with the exception of a few terracottas, up to the outbreak of the Second World War in 1939, is sculpture in stone or wood; there are a few pieces in carved cast concrete. Even between 1939 and 1945 there is a predominance of carved objects, but the 'sketch-models', usually in terracotta, increase, as if the sculptor wished to record his ideas in this

170 HENRY MOORE *Bird Basket* 1939

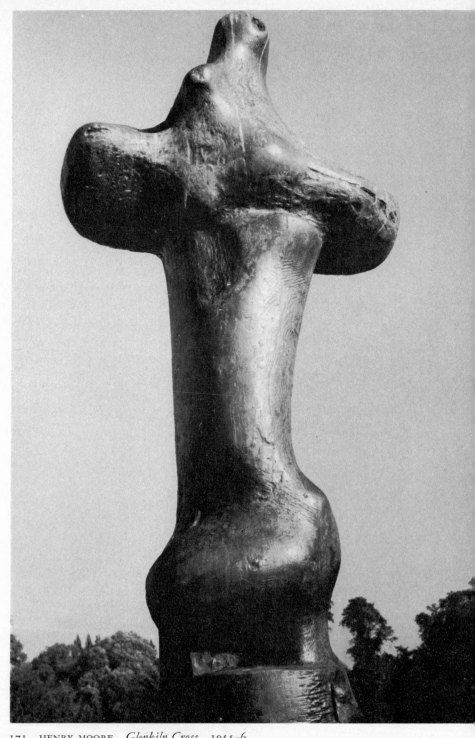

171 HENRY MOORE *Glenkiln Cross* 1955–6

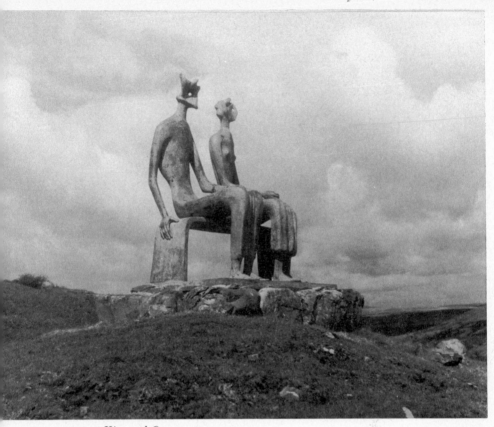

HENRY MOORE *King and Queen* 1952–3

emergency medium for later use when solid materials became available for large-scale versions of the same subjects.

From 1945 onwards the bronzes predominate, though from time to time it seems as if the sculptor must test his sense of form in direct carving. For example, the important *Internal and External Forms* first appears as a bronze maquette, 7 inches high (1951); then in the same year as *Working Model for Internal and External Forms*, 24½ inches high; next as a plaster model of the full-scale conception, 79 inches high. The final stage is the immense version carved in elm wood, 103 inches high (now in the Albright-Knox Art Gallery, Buffalo, USA). The screen for the Time-Life Building in

156

London (1952) went through a similar process of trans-
mutation – first four experimental maquettes in plaster, then
168 a working model cast in bronze, and finally the screen itself,
carved in Portland stone. But increasingly bronze was
envisaged as the final material, and the maquettes were
modified accordingly.

These technical developments, in such a scrupulous
artist, imply certain stylistic modifications, but between the
first characteristic reclining figures of 1929–30 and the latest
reclining figures of 1961–3 it is surprising how little the
forms have changed. Even discounting the persistence of
the same motif, such as the reclining figure, the only
decisive difference is one of surface rather than of mass, of
accent rather than of rhythm. What this means is that the
specific sculptural values – those of volume and surface-
tension – persist right through the artist's development,
and what changes (if anything changes) are merely the
wrinkles on the skin that covers the firm bone and flesh.
160 Compare, for example, the *Composition* in Cumberland
161 alabaster of 1931 with the bronze *Reclining Mother and Child*
167 of 1960–1; or even the 1929–30 reclining figures with the
173 monumental three-piece figures of 1961–3. The more they
differ, in material, scale and method of execution, the
more they are the same thing, the same conformation or
Gestalt.

Nevertheless, there is a development over the thirty years
of this artist's mature creative period, and it might be called
a development in archetypal consciousness. Ignoring
certain brief deviations, such as the stringed figures of
170 1937–40 (which nevertheless can be assimilated to the more
naturalistic motifs), there persists right through this artist's
career a deepening sense of the numinous – of the *mana*, or
animistic vitality, informing all natural forms – not only
those of organic beings, more particularly human beings,
but all inorganic things in so far as a structure has been given
to these by growth (e.g. crystals) or by natural forces (e.g.

176

HENRY MOORE *Three-piece Reclining Figure* 1961–2

the erosion of rocks by wind or waves). This sense of the
numinous may be an illusion, as the more materialistic type
of psychologist would maintain, or it may depend on
inherited reactions to our physical environment – there are
many hypotheses to account for it. In any case, the artist is
nearly always a man who is acutely aware of what Baudelaire
called 'correspondences' – that is to say, real but irrational
associations between disparate objects. To the poet these
correspondences may be of colour, sound or rhythm, but to
the sculptor they are always of *shape*. Moore himself has
said: 'There are universal shapes to which everyone is sub-
consciously conditioned and to which they can respond *if
their conscious control does not shut them off*' (that conditional
clause is important). Further:

177

174 HENRY MOORE *Sculpture* (*Locking Piece*) 1962

Although it is the human figure which interests me most
deeply, I have always paid great attention to natural forms,
such as bones, shells, and pebbles, etc. Sometimes for
several years running I have been to the same part of the
sea-shore – but each year a new shape of pebble has caught
my eye, which the year before, though it was there in
hundreds, I never saw. Out of the millions of pebbles
passed in walking along the shore, I choose out to see with
excitement only those which fit in with *my existing form-
interest* at the time. A different thing happens if I sit down
and examine a handful one by one. I may then extend *my
form-experience* more, by giving my mind *time to become
conditioned to a new shape.*[3]

178

175 PETER VOULKOS *Terracotta Sculpture*

GEOFFREY CLARKE *Battersea Group* 1962

177　OSCAR JESPERS　*Torso*　*c.* 1921

178　EUGÈNE DODEIGNE
Torso in Soignies stone　1961

The phrases which I have italicized indicate that in Henry Moore's experience there exists a buried treasury of universal shapes which are humanly significant, and that the artist may recognize such shapes in natural objects and base his work as a sculptor on the forms they suggest. He may become obsessed with one such significant form, but by accident rather than design he will become conscious of others, and select these for development in their turn.

Such, at any rate, has been the practice of this artist, and by his example he has initiated a world-wide development in

JOACHIM BERTHOLD *Stooping Man* 1960

180 JEAN-ROBERT IPOUSTEGUY
La Terre 1962

the art of sculpture – an alternative principle of creation.
That it is not entirely a new discovery we have already seen
– it was the principle that animated Early Greek, Etruscan,
Ancient Mexican, Mesopotamian, Fourth and Twelfth
Dynasty Egyptian, Romanesque and Early Gothic sculpture
and not least the sculpture of the primitive tribes of Africa
and Polynesia. Obviously it has inspired many diverse kinds
of sculpture, but in all these periods we find that the
classical ideal of beauty is not the aim of the artist, but this
alternative ideal of vitality, of integrated form and feeling.

181

But there is just one qualification to make to this general theory of vital form and we find Moore himself making it, with particular reference to the example of Brancusi. A form can be vital without thereby becoming a work of art – every animal or human being, every tree and flower, is vital, but the work of art is in some sense a concentration of this vital force. It is precisely this distinction which has made the work of Brancusi so important for the development of modern sculpture.

A sensitive observer of sculpture, [Moore said in the broadcast just quoted] must also learn to feel shape simply as shape, not as description or reminiscence. . . . Since the Gothic, European sculpture had become overgrown with moss, weeds – all sorts of surface excrescences which completely concealed shape. It has been Brancusi's special mission to get rid of this overgrowth, and to make us once more shape-conscious. To do this he had to concentrate on very simple direct shapes, to keep his sculpture, as it were, one-cylindered, to refine and polish a single shape to a degree almost too precious. Brancusi's

181 SALVATORE *Corrida*

MORICE LIPSI *Volvic Stone* 1958

183 COSTAS COULENTIANOS *Le Mollard* 1961

184 F. E. MCWILLIAM *Puy de Dôme Figure* 1962

185 MARIA MARTINS
Rituel du Rythme 1958

186 LUCIANO MINGUZZI *The Shadows* 1956

work, apart from its individual value, has been of
historical importance in the development of contemporary
sculpture. But [Moore concludes] it may now be no longer
necessary to close down and restrict sculpture to the
single (static) form unit. We can now begin to open out,
to relate and combine together several forms of varied
sizes, sections, and directions into one organic whole.[4]

This statement points clearly to the difference between
Brancusi's and Moore's work – the one clings to what
Wölfflin called 'closed form', the other proceeds to 'open
form'. It would be too confusing to equate this difference
with the difference that Wölfflin found between classical and

184

DENIS MITCHELL *Gew Form* 1960

188 ÉTIENNE BÉOTHY *Nocturno* 1956

189 ANDREA CASCELLA
The White Bride 1962

190 WILLY ANTHOONS
Infinite Form 1949–60

191 ALICIA PENALBA *Forêt Noir, no. 2* 19

192 PIETRO CASCELLA *Pygmalion* 1963

193 LORENZO GUERRINI *Mono macchina orizzontale* 1963

Baroque in Renaissance art – Brancusi is not a classical artist. He merely represents, in the formal development of modern sculpture, the outwardly simple as opposed to the outwardly more complex organic form – the fish or bird as opposed to the woman or the tree. But this is not a sentimental preference – not even a formal preference. 'Simplicity is not a goal,' Brancusi said with his perfect understanding of his art, 'but one arrives at simplicity in spite of oneself, as one approaches the real meaning of things' – one might say, as one approaches the numinous quality of things. Brancusi claimed that the art of wood-carving had been preserved only by Rumanian peasants (of whom he was one) and those African tribes which had escaped the influence of

187

194 HANS SCHLEEH *Abstract Form in Serpentine*

195 ALBERTO VIANI *Torso* 1956–62

HELEN PHILLIPS *Moon* 1960

Mediterranean civilization, 'thereby retaining the art of reanimating matter'.[5]

This animistic character of his work does not mean that Brancusi was any less conscious of the formal necessities of his art – on the contrary, he would have said that the form must be perfect to be worthy of the spirit. Ionel Jianou in his recent book on the sculptor suggests that Brancusi built his works the way a peasant builds his wooden house:

> He was concerned with the firmness and balance of volumes, with proportions, strength and structure. Most of his sculptures were projects, meant to be enlarged and erected like buildings in the open.

189

197 JAMES ROSATI *Delphi IV* 1961

198 RAFFAEL BENAZZI *Elmwood* 1962

199 ÉMILE GILIOLI *La Chimère* 1956

200 PIOTR KOWALSKI *Calotte 4* 1961

OLGA JANĆIĆ *Doubled Form* 1962

The problem was no longer that of integrating sculpture into architecture, as in the great synthesis of antiquity and the middle ages. On the contrary, Brancusi felt that a work of architecture should become a kind of inhabited sculpture.[6]

It was through Brancusi that a further characteristic of modern sculpture was established – respect for the nature of materials. It has more than once been observed that there is a decisive formal difference between Brancusi's sculptures in stone or metal and those in wood. Jianou suggests that

the choice of a medium was determined by the content. Marble lends itself to the contemplation of the origins of life, while wood lends itself more easily to the tumultuous expression of life's contradictions. Brancusi's intimate knowledge of the laws and structures of his materials enabled him to achieve perfect harmony between form and content.[7]

202 ERIK THOMMESEN *Woman* 1961 203 RAOUL HAGUE *Sawkill Walnut* 1955

Brancusi himself said that 'it is while carving stone that you
discover the spirit of your material and the properties
peculiar to it. Your hand thinks and follows the thoughts of
the material.'

This mystique of material, and of the correspondence
of form and content, has had a widespread influence on the
development of modern sculpture, and though it is not
possible to trace the influence in every case directly to
Brancusi (Arp, for example, though representing so many
of the same virtues, probably had a quite independent
development), nevertheless that influence has been decisive,
and is often acknowledged. Barbara Hepworth, for example,

WILLIAM TURNBULL *Llama* 1961 *(left)*

WILLIAM TURNBULL *Oedipus* 1962 *(right)*

206 BARBARA HEPWORTH
Pierced Form 1931

207 BARBARA HEPWORTH
Single Form 1935

whose work has been inspired by the same ideal of 'the
thinking hand discovering the thoughts of the material', has.
paid a very eloquent tribute to Brancusi; it must be quoted,
if only because it reveals history at the moment of its
making:

 In 1932, Ben Nicholson and I visited the Rumanian
sculptor Constantin Brancusi in his Paris studio. I took
with me to show to Brancusi (and Arp, and Picasso the
next day) photographs of my sculptures including ones of

206 the *Pierced Form* in alabaster 1931, and *Profile* 1932. In
both these carvings I had been seeking a free assembly of

194

BARBARA HEPWORTH
Forms 1937

209 BARBARA HEPWORTH
Pierced Form (amulet) 1962

certain formal elements including space and calligraphy as well as weight and texture, and in *Pierced Form* I had felt the most intense pleasure in piercing the stone in order to make an abstract form and space; quite a different sensation from that of doing it for the purpose of realism. I was, therefore, looking for some sort of ratification of an idea which had germinated during the last two years and which has been the basis of my work ever since.

In Brancusi's studio I encountered the miraculous feeling of eternity mixed with beloved stone and stone dust. It is not easy to describe a vivid experience of this

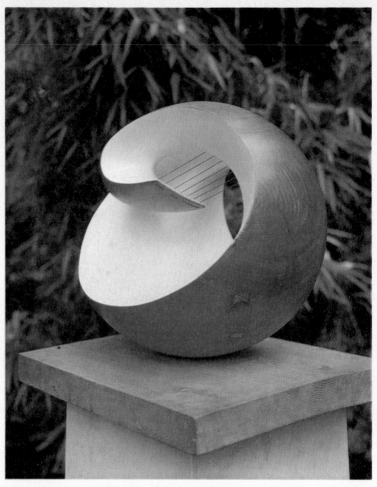

210 BARBARA HEPWORTH *Pelagos* 1946

order in a few words – the simplicity and dignity of the
artist; the inspiration of the dedicated workshop with
great millstones used as bases for classical forms; inches
of accumulated dust and chips on the floor; the whole
great studio filled with soaring forms and still, quiet
forms, all in a state of perfection in purpose and loving
execution, whether they were in marble, brass or wood –
all this filled me with a sense of humility hitherto unknown
to me.

BARBARA HEPWORTH *Single Form (Memorial)* 1961–2

212 LYNN CHADWICK *The Watchers* 1960

213 LYNN CHADWICK *Winged Figures* 1962

214 SEYMOUR LIPTON *Mandrake* 1959

I felt the power of Brancusi's integrated personality and clear approach to his material very strongly. Everything I saw in the studio-workshop itself demonstrated this equilibrium between the works in progress and the finished sculptures round the walls, and also the humanism, which seemed intrinsic in all the forms. The quiet, earthbound shapes of human heads or elliptical fish, soaring forms of birds, or the great eternal columns in wood, emphasized this complete unity of form and material. To me, bred in a more northern climate, where the approach to sculpture has appeared fettered by the gravity of monuments to the dead – it was a special revelation to see this work which belonged to the living joy of spontaneous, active, and elemental forms of sculpture.[8]

215 REG BUTLER *Project for Monument to the Unknown Political Prisoner* 1951–2

216 REG BUTLER *Study for a great Tower* 1963

DAVID SMITH *Royal Bird* 1948

218 DAVID SMITH
Cubi IX 1961

219 FRITZ WOTRUBA
Figure with raised arms 1956–7

220 FRANÇOIS STAHLY
Model for a Fountain

221 JOANNIS AVRAMIDIS
Large Figure 1958

Barbara Hepworth's work has been a rich development of the inspiration she received on the occasion of her visit to Brancusi. She lacks Brancusi's heritage of folklore myths, from which he always drew his inspiration – instead she has gone directly to nature, to crystals and shells, to rocks and the form-weaving sea. Like Moore, and indeed Brancusi also, she has kept the human figure as a *point de repère*, an ideal form to which all forms must be assimilated, for our better instinctive comprehension. But the forms and rhythms in her most characteristic work are emancipated from even this restraint, and conform to Brancusi's definition: 'Beauty is absolute equity.'

202

LOUISE BOURGEOIS
bing Figure 1950–9

223 PETER STARTUP
Falling Figure 1960

224 RUDOLF HOFLEHNER
Doric Figure 1958

FRITZ WOTRUBA *Reclining Figure* 1960

226 MIRKO
Composition with Chimera 1949

227 ÉTIENNE-MARTIN
Lanleff, demeure no. 4 1962

Absolute equity is perhaps also an emancipation from the more irrational aspects of vitalism. One does not associate equity, or equilibrium or symmetry, with some of the more chthonic of Moore's figures – the *Glenkiln Cross* of 1955–6, for example, or even the *King and Queen* of 1952–3. There is an element in Moore's work, not present in Brancusi, Arp or Hepworth, which comes from a deeper level of the unconscious – the Shadow, as Jung called it, and this element is distinctive of the work of many other sculptors of the vitalist tradition – of Alberto Giacometti, Germaine Richier, Theodore Roszak, Luciano Minguzzi, Reg Butler, Lynn Chadwick – and the occasional sculpture of the

171
172

139–42
146–8, 251
241, 186
215–6, 212–3

ÉTIENNE-MARTIN *Le grand Couple* 1949 (*right*)

ÉTIENNE-MARTIN *La Nuit* 1951 (*left*)

230 ANDRÉ VOLTEN *Architectonic Construction* 1958

231 NICOLAS SCHÖFFER *Spatiodynamique no. 19* 1953

232 HANS AESCHBACHER *Figure XI* 1960

233 JACQUES SCHNIER *Cubical Variations within rectangular Column* 1961

painters Max Ernst and Joan Miró. All these artists are in 143–5, 152–5 search of effective images, images that mediate between the chaos of the unconscious and the 'absolute equity' or order which art imposes on this chaos, in so far as it is released in moments of 'inspiration'.

Brancusi is particularly fertile in images which seem to mediate between primeval forces and metaphysical order – his *Adam and Eve* is the best example, a columnar carving in 46 which symbols of generation and fecundity are 'stylized' into precise geometric forms. Moore's *Glenkiln Cross* seems 171 to have a similar significance, but the form remains irregular – even the 'cross' is blunted and humanized, and the pedestal

234 GABRIEL KOHN
Encliticus Urbanus · 196

235 ROBERT ADAMS *Maquette for architectural Screen* 1956

236 HUBERT DALWOOD
Una grande Liberta 1963

or shaft deformed. There seems to be little to choose
between these two monuments, considered as 'effective
images'. We must not confuse order with regularity or
symmetry; there is an order that proceeds from the balance
or significant arrangement of irregular elements. In general
the modern preference, even in other arts like poetry and
music is, for a principle of indeterminacy, for forms in
dynamic rather than static relationship, for the fountain, as
Arp said in one of his poems, that tells formal fables.

It is perhaps a vain effort to gather under the one rubric
of vitalism so many of the disparate experiments of the
modern sculptor. The case of Giacometti presents a typical

209

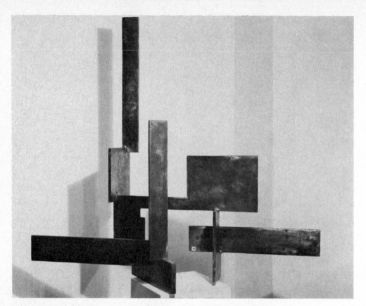

237 MARINO DI TEANA *Espace et Masse libérés—
hommage à l'architecture* 1957

238 CAREL VISSER
Fugue 1957

BERNHARD LUGINBÜHL *USRH (Space Clasp)* 1962

dilemma for the historian. There is no artist of the present day so concerned for the formal fable – the mystery of the object's occupancy of space. I have already referred to the Surrealist phase of Giacometti's work, his 'transparent constructions' that create a profound sense of disquiet. Since then Giacometti has advanced very slowly into the mysterious realm of space. It may be that there are people for whom space is no mystery, but the great scientists like Einstein are not among them, and certainly not great artists like Giacometti. There is a sense in which the space between myself and another person in the room, or the tree on the horizon, is more mysterious than the person or the tree – all vision is an uncertain mirage. 'The distance between one nostril and the other is like a Sahara, boundless and elusive.'[9] Preoccupied as Giacometti has been with these subjective considerations, immaterial as are the figures modelled to give expression to an evanescent emotion, nevertheless the figures he has created are 'personnages' – they are not apparitions, but icons; objects that *materialize* the mirage, effective images of the numinous, of the threshold that divides the ego from reality.

To create an *icon*, a plastic symbol of the artist's inner sense of numinosity or mystery, or perhaps merely of the unknown dimensions of feeling and sensation, is the purpose of the great majority of modern sculptors – one thinks immediately of Germaine Richier and Étienne-Martin; of the British sculptors Armitage, Chadwick, Dalwood and Paolozzi; of the Italians Mirko and Minguzzi; of the Americans Theodore Roszak and David Smith; and of many others. Critically, of course, one would have many distinctions to make, and it might seem, for example, that now little in common is to be observed between the later humanistic sculpture of Reg Butler and the impersonal robots of Eduardo Paolozzi. But from a more general point of view a common aim would seem to emerge from their very different formal conceptions. Butler's comprehensive

251, 227–9
254–6, 212–13
236, 269–70
226, 186
241, 217–18

272–3

ANDRÉ BLOC *Double interrogation* 1958

241 THEODORE ROSZAK *Night Flight* 1958–62

242 FRITZ KOENIG *Herd X* 1958

MICHAEL AYRTON *Icarus III* 1960

244 RALPH BROWN
Stepping Woman 1962

definition of the aims of the student of art would serve as an equally comprehensive definition of the aims of the modern artist in general:

The anatomical organization not merely of human beings but of animals, plants, bacteria, crystals, rocks, machines and buildings. The simplicity and complexity of their forms, their articulation, the disposition of stresses and strains in living and non-living structures. Recognition of the qualities of things; their hardness and softness, heaviness and lightness, tautness and slackness, smoothness and roughness. Recognition of unities and similarities, rhythms and analogues, differences. The character of

215

245 MARINO MARINI *Horse and Rider* 1949–50

246 MARINO MARINI
*Portrait of Igor
Stravinsky* 1951

space, the definition of space, the penetration of things
into space. The nature of illumination, its determination
of what we see (as opposed to what we know otherwise
than by vision from a static point in space). The news
value of colour. The way our reading of experience is
controlled by the means by which we perceive.[10]

The last sentence in this list is perhaps the most important,
for the quality of a work of art is always determined by a
subtle interrelationship between purity of perception and the
essence of things; that is to say, the 'essence', whether
it is Brancusi's 'absolute equity' or Giacometti's 'liquid
silver around me', or Paolozzi's 'rational order in the

217

247 MARINO MARINI *Dancer* 1954 248 EWALD MATARÉ *Torso* c. 192

technological world' that is 'as fascinating as the fetishes of a
Congo witch doctor', must be revealed by means which are
strictly aesthetic. It is temptingly easy to interpret the many
diverse phenomena of modern art as expressions of an
'Angst' or despair induced by the alienation prevailing in
our technological civilization – a 'geometry of fear', as I
once expressed it. In 1963 the city of Darmstadt organized
an impressive exhibition entitled 'Zeugnisse der Angst in
der moderner Kunst' – evidences of anxiety in modern art.
It included, among the sculpture, the work of Giacomo
Manzù, Marino Marini, Jacques Lipchitz, Max Ernst, Max
Beckmann, Germaine Richier, Lynn Chadwick, Kenneth

218

GIACOMO MANZÙ *Girl in Chair* 1955 250 EMILIO GRECO *Seated Figure* 1951

Armitage, Henry Moore, Reg Butler, Alberto Giacometti, Leonard Baskin, Theodore Roszak, Umberto Mastroianni and Agenore Fabbri – that is to say, the kind of sculpture I have been mainly concerned with in the present chapter. While one cannot question this general characteristic in the sculpture exhibited in Darmstadt, it is nevertheless based on 'a reading of experience' rather than on 'the means by which we perceive' – on the content rather than the form. There is no anxiety in the art of Brancusi, and anxiety is not an exclusive sentiment in the work of Moore, Hepworth or Butler, however much it may have been the settled mood of artists like Giacometti or Germaine Richier. Anxiety

251 GERMAINE RICHIER *The Bat* 1952

252 ELIZABETH FRINK
Harbinger Bird III 1960

ROBERT CLATWORTHY *Bull* 1956–7

254 KENNETH ARMITAGE
Walking Group 1951

(even as a pathological condition) is seldom unmixed with hope: the mind of man alternates between a sense of despair and a sense of glory. At the conclusion of an article which he contributed to the catalogue of the above-mentioned Darmstadt Exhibition the German art critic,

255 KENNETH ARMITAGE *Figure lying on its side* (5th version) 1958–9

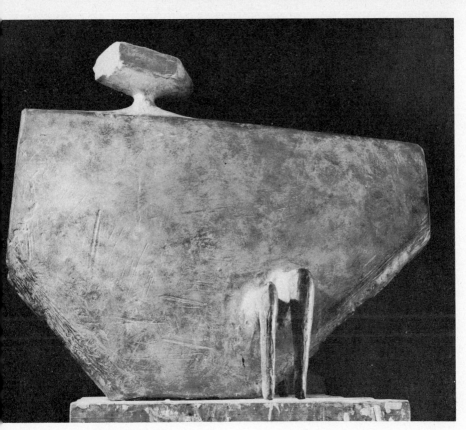

KENNETH ARMITAGE *Slab Figure* 1961

Werner Haftmann, made the following profound observation:

> If I now once again look back over my whole presentation [of the exhibition], then it seems to me as if I must, as it were from behind, write everything again, and from a directly contrary point of view. For what I describe, that was just a partial aspect, not more than the reverse of a much more comprehensive whole. Anxiety – so we say – has as its opposite, 'the Utopian perspective'. But this bears the name of Hope. Under that sign everything would have to be written anew and seen anew. Such a task has not been assigned to me. The exhibition is

257 UMBERTO MASTROIANNI
Conquest 1954

258 RUDOLF BELLING
Dreiklang Model 1919,
cast 1950

259 HANS P. FEDDERSEN *Composition* 1963

concerned with anxiety in our time. Its question is
absolutely legitimate so long as we realize that it is only
part of the question. This we know: that in any complete
view of the question we must include the hopes as well
as the anxieties of our time.[11]

The artist unconsciously projects the anxieties of his age,
but he would have no creative energy if he were completely
filled with despair. Every artist acts on the assumption
expressed by William Blake: *Energy is Eternal Delight*.

This chapter has been too discursive. I will conclude with a
list of fifteen significant pieces of modern sculpture which,

260 BERNARD MEADOWS *Large Flat Bird* 1957

with the aid of the accompanying illustrations, will enable the reader to trace the chronological development of vitalism in modern sculpture.

4	I	1893–7	Rodin, *Monument to Balzac*.
3		1893	Medardo Rosso, *Conversazione in Giardino*.

These two works, begun in the same year, are a first decisive departure from classical restraint in sculpture. The ideal is no longer 'beauty' but 'vitality'.

54	II	1909–10	Picasso, *Head of a Woman*.

A translation of the dynamics of Cubism into three-dimensional form.

261 RAOUL UBAC *Relief*

262 DUSAN DZAMONJA *Metal Sculpture, no. 3* 1959

For the sake of simplicity I have restricted this 'chart' to twelve stages of development, but it should be realized that the process was continuous, and that several other sculptors (Laurens, Pevsner, Miró, Butler, Marino Marini, Étienne-Martin, Chadwick, Armitage, Karl Hartung, François Stahly, and many others) have made decisive contributions to the vital image in modern sculpture.

263 LEONARD BASKIN
Owl 1960

A Diffusion of Styles

By comparison with the art of painting, the post-Second World War development of the art of sculpture shows a certain lack of cohesion or definition. In painting there has been an increasing emphasis on Abstract Expressionism and we have seen the emergence of a new school of 'action painting'. Action painting, though a distinct movement with a geographical location (the United States of America and more particularly the city of New York) is a 'logical' development of the Expressionist style, and what is distinctive about it (immersion in the medium, surrender to 'concrete pictorial sensations') is essentially painterly. The sculptor cannot paraphrase Pollock's well-known statement and say: 'When I am *in* my sculpture, I am not aware of what I'm doing.' The sculptor (despite some brave attempts by Étienne-Martin) must inevitably remain outside his sculpture, a conscious craftsman.

Nevertheless one can perhaps attempt some classification of all this post-war ferment in the art of sculpture, though admittedly, as I said in *A Concise History of Modern Painting*, this is a critical rather than an historical task. We are confronted by a diffusion of styles, the exploitation of inventions, the ceaseless experimentation with new materials, and not by the deployment of any coherent 'movements'. Styles or schools exist – or have existed: Impressionism, Post-Impressionism, Cubism, Constructivism, Surrealism, Expressionism, Abstract Expressionism; and the individual artist, according to his temperament, 'belongs' to one or another of them, much in the same manner as an individual Christian belongs to one of the Christian sects.

264 CÉSAR *The Man of Saint-Denis* 1958

What is distinctive about the post-war situation, particularly in sculpture, is a determination to belong to no movement, an artistic 'free thinking'. This attitude has perhaps always been characteristic of the great masters in any period. In our own time Picasso has been the springboard of several new movements but has consistently refused to be identified with any one of them. The sculpture of Henry Moore can be claimed, with good reasons, for Surrealism, but Moore himself does not subscribe to this or any other movement. But this does not mean that the artist, however great and independent, can dispense with his springboard. The situation has been described with his usual acumen by Harold Rosenberg:

> In our era, it is the art movements that make possible continuity of style, that stimulate interchanges of ideas and perceptions among artists, that provide new points of departure for individual inventions. The criss-cross of the art movements through time and place binds modern art into a whole that provides the intellectual and imaginative background for individual paintings.[1]

For individual sculptures, too, and it may be, as Rosenberg goes on to claim, that the present reaction against any collective manifestation is 'stiffened by the individualism that has become the militant creed of the post-war West. That the artist is capable of creating a thing that is entirely his own is, we are often told, the essential meaning of art in an age of mass production and conformism.'

Nevertheless – and this is the conclusion Mr Rosenberg comes to – movements redeem the individual artist and give a communal significance to his work. They do this, para-doxically, by intensifying the individualism of the genuine artist.

In the shared current, individuality, no longer sought for itself, is heightened. . . . Far from constricting the artist's imagination, the movement magnetizes under the motions of his hand insights and feelings from outside the self and perhaps beyond the consciousness. The living movement is a common direction of energies rather than a set of concepts, and any definition of it will apply to individual artists in it only to a limited degree – to the best artists least of all.

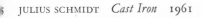

JULIUS SCHMIDT *Cast Iron* 1961

266 JAMES WINES *Corona I* 1962

It may be that the many movements in modern art will, to
the historian a century hence, fuse into one movement – a
movement like or allied to mannerism and romanticism.
But a movement, if it is strong enough, always provokes a
counter-movement, usually at an interval of time. I believe
that the complexity of the modern scene is partly due to the
co-existence of such movements and counter-movements,
that the romanticism of a Picasso (not to complicate matters
by considering the classicism of a Picasso) is matched in our
time by the classicism of a Mondrian, the vitalism of a
Moore by the 'realism' of a Gabo, etc. Characteristic of our
time, too, is a phenomenon which we might call sentimental

267 JASON SELEY *Magister Ludi* 1962

revivalism: the Dada movement of 1916–18 becomes the
neo-dadaism of the present day, the only difference being
that what was born in stress and motivated by revolutionary
zeal is revived by choice and motivated by nostalgia. All the
original movements of the modern period have either
continued unbroken for half a century or have gone under-
ground for a few years (i.e. lost their immediate appeal) to
reappear stylistically identical but emotionally impoverished
twenty or thirty years later.

In such circumstances it would serve no purpose to
describe such revivals – it is better to refer work now
produced to its stylistic origins, to relate a Rauschenberg

233

268 PABLO PICASSO
Baboon and Young 1951

269 EDUARDO PAOLOZZI *Head* 1957

or a Westermann to a Schwitters or a Picabia. Among the
hundreds of sculptors who have emerged since 1945, it
seems to me that there is only one who might claim to have
invented a new *style* – Eduardo Paolozzi. This is not to
discount the originality of sculptors like César, Robert
Müller, Fritz Wotruba, Germaine Richier, Theodore
Roszak, Berto Lardera, Richard Lippold and many others;
but it is possible to make original contributions to an
existing movement, which I think all these sculptors do,
without inventing a new idiom, which is what Paolozzi has
done in his most recent 'engineered' constructions (*The City
of the Circle and the Square*, 1963; *Wittgenstein at Cassino*, 1963;

273

270 EDUARDO PAOLOZZI
Japanese War God 1958

271 EVA RENÉE NELE *The Couple* 1961

The World divides into Facts, 1963; etc.). Until this recent de-
velopment, which begins in 1961, it was still possible to relate
Paolozzi's work to the work of Richier or César, and
ultimately to Picasso's (*Baboon and Young*, 1951). But his 268
new images, functionless machine-tools or sterile computers,
derive not, like his previous work, from the débris of
industrialism, but from the rational order of technology. I
have already quoted his statement that idols representing
such an order 'can be as fascinating as the fetishes of a
Congo witch doctor', but a mechanical fetish does not have
the same function as a tribal fetish – or rather, it 'functions'
in a totally different kind of society, a society whose mental

272 EDUARDO PAOLOZZI *Hermaphroditic Idol, no. 1* 1962

processes aspire to logical consistency. By naming some of these constructions 'idols', Paolozzi gives further encouragement to an animistic interpretation of his work; but what is consistent is the realized or incorporate contradiction: as if the mechanical computer had finally achieved a soul, and with that apotheosis ceased to function as a machine.

273 EDUARDO PAOLOZZI *The City of the Circle and the Square* 1963

Since the present sculptural activity throughout the Western world is not dominated by any unitary style, the historian can attempt only a descriptive classification. He then becomes aware of one astonishing development: the prevalence of metalwork. It would seem, judging from the works exhibited in commercial galleries, that almost four-fifths of

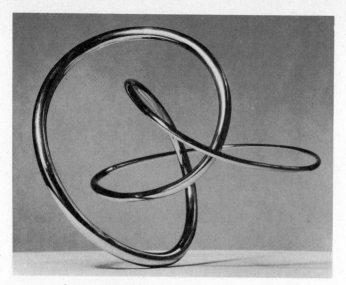

274 JOSÉ DE RIVERA
Construction, no. 35 1956

275 ROBERT MÜLLER *Archangel* 1963

276 DAVID GOULD *Welded Iron* c. 1962

HERBERT FERBER
age to Piranesi 1962–3

278 RICHARD STANKIEWICZ
Untitled 1961

all contemporary sculpture is made of metal of some kind. It is possible to speak of a 'New Iron Age'.

Some of the reasons for this development have already been mentioned – the fact, above all, that we live in a civilization that is largely dependent on metallurgy for its machinery of production and distribution. It is true that latterly industry's dependence on natural metals has been challenged by the invention of various synthetic materials, a develop-

ANTHONY CARO *Lock* 1962

280 BRUNO GIORGI *Two Amazons* 1963

281 IBRAM LASSAW
Counterpoint Castle 1957

ment which artists have also noticed and exploited; but
metals such as bronze, steel, iron and aluminium remain
the characteristic materials of our civilization and have
decisive virtues for sculpture – they can be cut, welded,
moulded, cast, polished or patinated, and the final result has
a durability that exceeds all but the hardest stones.

282 HAROLD COUSINS *Gothic Landscape* 1962

GEORGE RICKEY
er III 1962–3

284 BRIGITTE MEIER-DENNINGHOFF
Gust of Wind 1960

Discounting the ideological motives that might lead the sculptor to the choice of metal (iron, etc., as materials with a certain symbolic appeal), the main justifications for this development would seem to be two: 1. accessibility of ready-made material; 2. ease of construction.

In the past fifty years suitable stone or wood for sculpture has become not only more difficult to obtain, but also far more costly. Against its cost one must balance the even higher cost of casting bronze, but in the development I am referring to, casting is not necessarily in question. Bronze casting is one of the oldest and most widespread of techniques in sculpture, but it was always conceived as a method

241

285 WALTER BODMER *Metal Relief* 1959

of giving permanence to objects previously moulded, and as an exploitation of the sensuous qualities of bronze as a material. But that is not the modern sculptor's approach to metal as a medium. It is true that sculptors like Moore and Giacometti, Marini and Lipchitz, still seek to exploit the sensuous qualities of bronze and attach great importance to its surface qualities. But in general this is not the motive of the modern sculptor in metal, who will even despise such

286 RICHARD LIPPOLD *Variations within a Sphere, no. 10: The Sun* 1953–6

NORBERT KRICKE *Space Sculpture* 1960

288 MARY CALLERY *A* 1960

289 MARY VIEIRA *Tension-Expansion (Rythmes dans l'Espace)* 1959

290 ALEXANDER CALDER *Stabile (Le petit Nez)* 1959

'finish' and seek to exploit the crude qualities of the wrought
or cast material ('un art *brut*', to correspond with the same
qualities in certain types of modern architecture).

Metals in general have certain unique qualities – they are
ductile, which means that they can be drawn out into wires,
and they are *malleable*, which means that they can be shaped
into form by hammering; and they can be melted and cast,
moulded into predetermined shapes or pressed. The
modern sculptor takes advantage of all these possibilities, 66–7, 215
so we get wire sculpture (Picasso, Calder, Butler, Lassaw, 281, 285–7
Bodmer, Lippold, Kricke, David Smith, José de Rivera, 217, 274
Mary Vieira, Bill and many others), welded sheet iron 289

291 BERTO LARDERA *Slancio temerario, no. 2* 1958–9

292 · ROBERT JACOBSEN *Noir Rouge* 1962

(Lardera, Jacobsen, César, Müller, Stankiewicz, Kneale,) 291–2 264
Hoflehner, etc.), wrought iron or steel (Baldessari, 275, 278
Uhlmann, Hoskin, Chillida) and many combinations and 295, 224
variations of these techniques (the works of Antoine 301–2, 308
Pevsner, for example, exploit a metal craftsmanship of great 299, 113–14
skill and subtlety; Chadwick has invented his own tech- 212–13
niques for his castings). In general, metal is so docile that it
will submit to any formal conception the sculptor may have,
and it is this adaptability that explains its present general use.

293 GIORGIO DE GIORGI *La Colombe du Cap* 1961 294 OSCAR WIGGLI *Untitled* 19

295 BRYAN KNEALE *Head in Forged Iron* 1961

ROËL D'HAESE *La Nuit de Saint Jean* 1961 297 FRANCO GARELLI *Non Lasciarmi* 1962

298 EDGARDO MANNUCCI *Resumption of idea, no. 3* 1951–7

299 EDUARDO CHILLIDA
Enclume de Rêve, no. 10 1962

300 HANS UHLMANN
Rondo 1958–9

One must then ask a devastating question: to what extent does the art remain in any traditional (or semantic) sense *sculpture*? From its inception in prehistoric times down through the ages and until comparatively recently sculpture was conceived as an art of solid form, of *mass*, and its virtues were related to spatial occupancy. It was for his restoration to the art of its characteristic virtues that Rodin was praised, and as we have seen, Rodin's followers, Maillol, Matisse, Bourdelle, Lehmbruck, Brancusi, Laurens, Arp (above all, Arp) and even Moore have been and are still sculptors in this traditional sense. What has been gained, and what has been lost, by this transition to a *linear* sculpture?

301 HANS UHLMANN *Steel Relief* 1959

302 HANS UHLMANN *Sculpture for the Berlin Opera House* 1961

303 STEPHEN GILBERT *Structure* 1961 304 JAMES METCALF *Ying Yang doré* 1963

305 MAX BILL *Endless Loop, no. 1* 1947–9

306 WANDER BERTONI *C (Imaginary Alphabet)* 1954-5

Virtually everything, one must say, has been lost that has
characterized the art of sculpture in the past. This new
sculpture, essentially open in form, dynamic in intention,
seeks to disguise its mass and ponderability. It is not
cohesive but cursive – a scribble in the air. Far from seeking
a point of rest and stability on a horizontal plane, it takes off
the ground and seeks an ideal movement in space. Far from
conforming to the ideal of *containment*, it is essentially articu-
lated, and accosts the spectator with aggressive spikes. It
may sometimes present a polished surface, but only to
emphasize a predominant roughness. Further, to evade any
suggestion of intentional craftsmanship, it will resort to
scrap metal and use the machine hammers and compressors

253

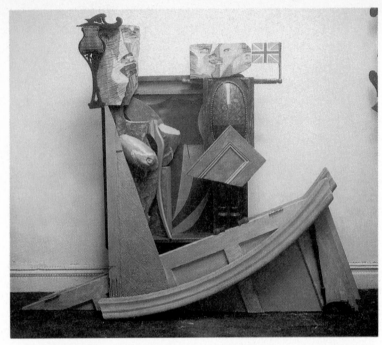

307 GEORGE FULLARD *The Patriot* 1959–60

308 JOHN HOSKIN *Boltedflat* 1963

JEAN DUBUFFET *Abrantegas* 1960 310 LESLIE THORNTON *The Martyr* 1961

of the demolition yards to press such ready-made material
into informal conglomerates (Chamberlain, César). 335–6

What is the destination of such horripilate shapes? A
number of them inevitably find their way into museums of
modern art; a few break with their aggressive forms the
blank walls of functional buildings; others become 'decora-
tive features' in parks or exhibitions. Some small pieces may
be acquired by private collectors, but essentially this is a
public art, a display art, and is directed, not to the private
sensibility, but to the collective unconscious. Beauty, of
course, is no longer the artist's aim; but even conceding the
alternative virtue of vitality, one must still question the
nature of that vitality. Moore's ideal, while distinct from the
traditional concept of beauty, conforms to what we might
call the organic mode; he still finds his prototypes in natural
objects. This is also partially true of the metalworkers;
a bird's skeleton or a lobster is a natural form, and an

255

311 JEAN TINGUELY *Monstranz* 1960 312 SHINKICHI G. TAJIRI *Relic from an Ossuary* 1957

organically vital form. But the characteristic forms of the new iron age do not even have the structure of a skeleton: the figures of Germaine Richier, though they may refer to natural prototypes (e.g. *The Bat*, 1952) present their prototypes in a state of decay or disorganization.

251

Such artists, in short, are concerned with the effect known to philosophers of art as *terribilità*. Even in the eighteenth century a philosopher like Edmund Burke came to the conclusion that ugliness might be 'consistent enough with an idea of the sublime. But I would by no means insinuate [he added] that ugliness of itself is a sublime idea, unless united with such qualities as excite a strong terror.'[2] This is not the

FRANCESCO SOMAINI *Grand blessé, no. 1* 1960

314 PETER AGOSTINI
Hurricane Veronica 1962

place to enter into a discussion of the place of ugliness in art,[3] but it has a function for which adequate psychological explanations may be found. The whole conception of tragedy is based on a recognition of the shadow in our souls, the dark powers of hatred and aggression. But in tragedy, in its classical form, these dark powers are redeemed by heroism, and the soul is purged of its errors. One can still find catharsis in the terrible realism of Grünewald's *Crucifixion* or Goya's *Disasters of War*. There is no Goya or Grünewald among these sculptors in metal. But their works stick like burrs on our bourgeois sensibility, their function not catharsis but mortification.

257

315 ÉTIENNE HAJDU *Delphine* 1960 316 VOJIN BAKIĆ *Deployed Form* 1961

A survey of the many styles prevailing in sculpture today would reveal other types whose classification would be merely pedantic. There are various forms of eclecticism – for example, the Oriental influences that appear, quite naturally, in the sculpture of Isamu Noguchi. The influence of early Greek art (particularly of the subtle relief of Greek *stele*) is found in Étienne Hajdu's work. Etruscan influences can be traced in the characteristic work of Marino Marini. Primitive or tribal sculpture continues to exert a general influence. All this is part of the eclecticism characteristic of modern art in general, and needs no further comment.

<div style="text-align:left">317–18</div>
<div style="text-align:left">315</div>
<div style="text-align:left">245</div>

258

ISAMU NOGUCHI *Black Sun* 1961–2 (*right*)
ISAMU NOGUCHI *Study from a Mill Stone* 1961 (*left*)

319 HANS-JÖRG GISIGER *Rhéa* 1959

320 FRIEDERICH WERTHMANN
Entelechie II 1960

321 CLAIRE FALKENSTEIN
Point as a set, no. 10 1962

322 QUINTO GHERMANDI *Momento del volo* 1960

ILHAN KOMAN *Miroir II* 1962

324　HENRI-GEORGES ADAM　*Trois Pointes*　1959

325　PIETRO CONSAGRA
Colloquio con la Moglie 1960

326 HARRY BERTOIA *Urn* 1962

There remains another category which only doubtfully qualifies as sculpture in any sense of the word, but is usually included in exhibitions of sculpture – those 'assemblages' of diverse ready-made objects designed to amuse or shock rather than to create any aesthetic emotion. Historically they derive from the ready-mades of Marcel Duchamp, already mentioned, and from Man Ray's witty confrontation of incongruous objects.

In so far as such assemblages are relief constructions, they carry on the inventions of Schwitters (see page 145) who, in his Hanover *Merzbau* of *c.* 1924, created the prototype of all subsequent three-dimensional assemblages. The Surrealists extended the conception into the realms of fantasy (Ernst, Miró, Brauner, Paul Nash). With Joseph

125
134, 143–5
152–5
136–8

263

327 JOSEPH CORNELL *Shadow Box. Interior white with yellow sand and 'sea-side' atmosphere*

327 Cornell's 'boxes' a new and fertile invention was intro-
duced, the idea of a 'compacted' treasury of curiosities.
William C. Seitz has described them as 'the hermetic secrets
of a silent and discreet Magus . . . hieratic talismans like the
highly treasured possessions of a child – anything: a Haitian
postage stamp, a clay pipe, a compass, even the Night'.[4] But
though such boxes occupy space and are displayed like
sculptural objects, they approximate to furniture rather than
to sculpture.

328 The same cannot be said of Louise Nevelson's assem-
blages, though these are often contained within a box-like
frame. But others stand freely, without a frame, or are

LOUISE NEVELSON *Royal Tide V* 1960

329 LEONARDI LEONCILLO *Sentimento del tempo* 1961

even suspended in space. Her material is an individual choice – newel posts, chair or table legs, balusters and finials, pieces of moulding, simple blocks of wood. These are selected and mounted in compartments, and each compartment is a separate and satisfying composition. The

330 JOHN WARREN DAVIS *Imago, no. 2* 1963

whole assemblage may be left in its natural colour, or painted
black or gold. The general effect is that of relief sculpture,
and from a strictly formal point of view there is nothing to
distinguish a Nevelson construction from a relief by Nicola
Pisano or Agostino di Duccio. Her work is serious and even

267

331 LUCIO FONTANA *Concetto Spaziale* 1962

332 ZOLTÁN KEMENY *Banlieu des Anges* 1958

3 BERNARD ROSENTHAL *Riverrun* 1959 334 PHILIPPE HIQUILY *Calvary* 1962

severe; which is perhaps more than can be said for a stack
of compressed scrap automobile bodies, such as César and 335–6
Chamberlain offer us.

Here is a description of César at work:

> ... In a factory for the salvaging of metals in the suburbs
> of Paris I saw César in front of one of the latest American
> compressors, supervising the movements of the cranes,
> proportioning the heterogeneous loads, eagerly awaiting
> the results of each operation. Together we admired these
> calibrated bales weighing nearly a ton which are the
> product of the compression of a small lorry, a pile of
> bicycles or of a gigantic set of kitchen stoves.

269

335 JOHN CHAMBERLAIN *Untitled* 1960

. . . César sees in the result of this mechanical com-
pression a *new stage of metal*, one subjected, so to speak, to
a quintessential reduction. . . .

. . . For beyond the American neo-dadaist provocations
his œuvre opens one of the roads to the *new realism*; it is
high time that the public recognized that this realism is
the essential achievement of this second half-century.[5]

270

CÉSAR *Relief* 1961

With this achievement we may take leave of the history of modern sculpture. Realism has had many definitions since it was first introduced as an aesthetic category rather more than a hundred years ago. It was then used (mainly in defence of Courbet) as a category opposed to idealism, and there can be few critics who would question its beneficial workings as a principle of art. But all categories of art, idealistic or

271

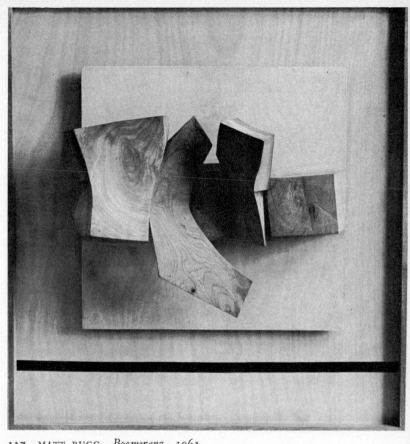

337 MATT RUGG *Boomerang* 1963

realistic, surrealistic or constructivist (a new form of idealism) must satisfy a simple test (or they are in no sense works of art): they must persist as objects of contemplation. For contemplation we might with some aesthetic justification substitute *fascination*, which would correspond to Henry Moore's distinction between beauty and vitality. But while contemplation leads to serenity and love, the fascination of the 'new realism' can only arouse horror and hatred. Ruskin, as usual, stated this truth in his incomparable way, and his prophetic words shall complete this brief history of a complex subject:

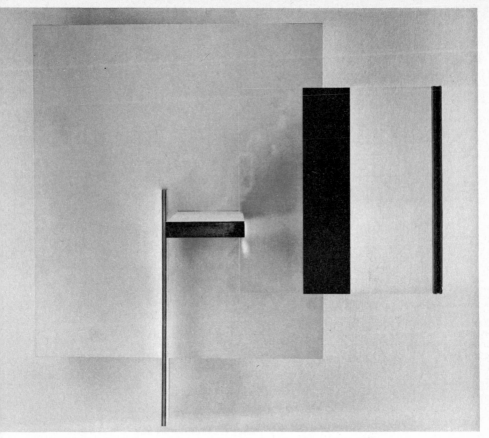

VICTOR PASMORE *Relief construction in white, black and indian red* 1962

The worst characters of modern work result from its constant appeal to our desire of change, and pathetic excitement; while the best features of the elder art appealed to love of contemplation. It would appear to be the subject of the truest artists to give permanence to images such as we should always desire to behold, and might behold without agitation; while the inferior branches of design are concerned with the acuter passions which depend on the turn of a narrative, or the course of an emotion. Where it is possible to unite these two sources of pleasure, and, as in the Assumption of Titian, an action of absorbing

273

interest is united with perfect and perpetual elements of beauty, the highest point of conception would appear to have been touched: but in the degree in which the interest of action *supersedes* beauty of form and colour, the art is lowered; and where real deformity enters, in any other degree than as a momentary shadow or opposing force, the art is illegitimate. Such art can exist only by accident, when a nation has forgotten or betrayed the eternal purposes of its genius, and gives birth to painters whom it cannot teach, and to teachers whom it will not hear. The best talents of all our English painters have been spent in endeavours to find room for the expression of feelings which no master guided to a worthy end, or to obtain the attention of a public whose mind was dead to natural beauty, by sharpness of satire, or variety of dramatic circumstance.[6]

Ruskin wrote this in 1854. I do not know which 'English painters' he had in mind; but the situation he describes is still the same, throughout the world: a public whose mind is dead to natural beauty, and artists driven by this prevailing apathy to give 'dramatic circumstance' to the expression of their feelings.

339 KENNETH MARTIN
Oscillation 1962

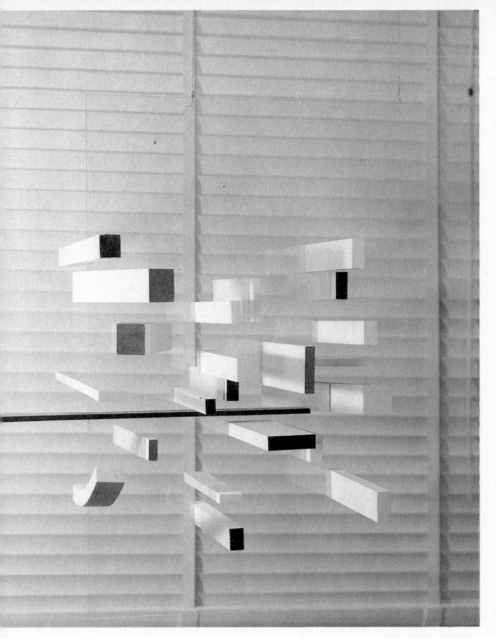

VICTOR PASMORE *Abstract in white, ochre and black. Transparent projective relief* 1963

Text References

Select Bibliography

List of Works Reproduced

Index

Text References

Chapter One

1 *The Listener*, 8 November 1962, vol. LXVIII, No. 1754, p. 774.

2 *The Tradition of the New*, New York (Horizon), 1959; London (Thames & Hudson), 1962.

3 G. Baldinucci, *Vocabulario Toscano dell'arte del disegno*, Florence, 1681. Quoted from E. Kris, *Psychoanalytic Explorations in Art*, New York, 1952, pp. 189–90. Kris, in collaboration with E. H. Gombrich, devotes a chapter to 'The Principles of Caricature'.

4 Auguste Rodin, *L'Art – entretiens réunis par Paul Gsell*, Lausanne (Mermod), 1946.

5 Cf. John Rewald, *The History of Impressionism*, New York (Museum of Modern Art) and London (Mayflower Books), 1961, p. 551.

6 Rewald, *ibid.*, pp. 336, 338.

7 *Auguste Rodin*, Berlin, 1903; Leipzig, 1913, trans. Jessie Lemont and Hans Trausil, London (Grey Walls Press), 1946, p. 45.

8 Andrew C. Ritchie (ed.), *Aristide Maillol*, Buffalo (Albright Art Gallery), 1945.

9 For an illuminating analysis of Rodin's relation to Rosso cf. Margaret Scolari Barr, *Medardo Rosso*, New York (Museum of Modern Art), 1963. Cf. also Albert E. Elsen, *Rodin*, New York (Museum of Modern Art), 1963, pp. 96, 105 (n. 26).

10 *The Art of Sculpture*, New York (Bollingen Series) and London (Faber & Faber), 1956, pp. 56, 67-8, 71.

11 Biographical Note in the catalogue of an exhibition of his work held at the Curt Valentin Gallery, October–November 1951. The catalogue also contains a charming letter to Valentin which reveals the sculptor's essential humanism better than any theoretical statement could do.

12 Both illustrated on p. 445 of *Post-Impressionism from van Gogh to Gauguin* by John Rewald, New York (Museum of Modern Art) and London (Mayflower Books), 1956.

13 From a contemporary review of the exhibition reprinted in J. K. Huysmans, *L'Art moderne*, Paris, 1883, 1902. Reference from Rewald, *The History of Impressionism, op. cit.*, pp. 450, 479.

14 *Journal* (1889–1939), Paris, 1939, p. 202 (entry of 17 March).

15 Raymond Escholier, *Matisse from the Life*, trans. Geraldine and H. M. Colvile, London (Faber & Faber), 1960, p. 138.

16 Escholier, *ibid.*, pp. 140–1.

17 For the significance of 'haptic values' in sculpture, see my *Art of Sculpture, op. cit.*, pp. 30–1.

18 Alfred H. Barr, Jr., *Matisse: His Art and His Public*, New York (Museum of Modern Art), 1951, pp. 550–2.

19 Catalogue of a retrospective exhibition of Matisse's work held at the Museum of Art, Philadelphia, 1948.

Chapter Two

1 *The Complete Letters of Vincent van Gogh*, London (Thames & Hudson), 1958, vol. 3, p. 521.

2 *Ibid.*, vol. 3, pp. 179–80.

3 The influence of primitive art on Gauguin appears chiefly in his paintings. Bernard Dorival has documented this aspect of Gauguin's art in 'Sources of the Art of Gauguin from Java, Egypt and Ancient Greece', *Burlington Magazine*, April 1951, vol. XCIII, pp. 118–23.

4 *The autobiography of Alice B. Toklas*, New York, 1933; London (Hutchinson & Co Ltd), 1960.

5 Whether similar developments in German Expressionist painting can be traced to the same origins is perhaps open to question. Certain of the German painters, Emil Nolde and Ernst Ludwig Kirchner, for example, had direct knowledge of African or Oceanic sculpture. Equally, of course, they had direct knowledge of the paintings of Van Gogh and Gauguin.

6 'Tribal Art and Modern Man', *The Tenth Muse*, London, 1957, pp. 309–10.

7 Cf. *The Nature of Representation* by Richard Bernheimer, New York University Press, 1961. This 'phenomenological inquiry' is a work of profound significance for the understanding of the concept of representation in the visual arts.

8 Particularly in *Art and Society*, New York and London (Faber & Faber), 3rd ed., 1956, and *Icon and Idea*, Cambridge, Mass., and London (Faber & Faber), 1955.

9 *Abstraction and Empathy*, 1908, trans. Michael Bullock, London (Routledge & Kegan Paul), p. 24.

Chapter Three

1 For the origins and first use of the word, cf. John Golding, *Cubism: a History and Analysis 1907–14*, London (Faber & Faber), 2nd edition, 1968, *passim*. Cf. also D.-H. Kahnweiler, *Entretiens*, Paris, 1961, p. 51: 'Mais celui qui a inventé le mot "cubisme" sans aucun doute . . . c'est Louis Vauxcelles. . . .'

2 Cf. Fernande Olivier, *Picasso and his Friends*. Trans. Jane Miller. London (Heinemann), 1964.

3 Jean Revol, 'Braque et Villon: message vivant de Cubisme', *La nouvelle revue française*, August–September 1961.

4 Cf. D.-H. Kahnweiler, *op. cit.*, p. 78: 'Quand je dis les cubistes, évidemment il faut comprendre toujours que c'est Picasso dans "Les demoiselles d'Avignon" qui a commencé. . . . La moitié droite des "Demoiselles d'Avignon" est une première tentative absolument héroïque de resoudre tous ces problèmes à la fois car, en somme, on ne voulait pas seulement donner la forme exacte des objets mais aussi leur couleur exacte.' Cf. also Marie-Alain Coutourier, *Se Garder libre* (*Journal, 1947–54*), Paris, 1962, p. 158: 'Mars 53. . . . L'autre soir, chez Braque, je lui demande ce que Picasso et lui avaient dans le tête quand ils ont commencé à faire du cubisme.

'"D'abord," me dit-il, "nous n'avons jamais fait de cubisme. Ce sont les autres, après nous, qui en ont fait."

'Je lui dis qu'il devrait parler, dire comment les choses se sont passées. Mais il me dit que c'est inutile. "Il n'y a rien à faire, on est en train de *faire* l'histoire du cubisme. Elle est absolument fausse. Mais il n'y a rien à faire: l'histoire se fait comme cela. Les gens qui écrivent l'histoire ne sont jamais ceux qui l'ont faite; et les seconds ne peuvent rien contre les premiers."'

5 Cf. Pierre Courthion, *Gargallo: sculptures et dessins*, Paris, 1937, p. 15 n.

6 Roland Penrose, *Picasso: His Life and Work*, London (Gollancz), 1958, p. 241.

7 Cf. Claude Levi-Strauss, *La pensée sauvage*, Paris, 1962, p. 21.

8 *The Principles of Art*, Oxford University Press, 1938, pp. 66, 68–9.

9 This date is given by Kahnweiler. Barr and Penrose give 1928, which would imply that they preceded the Boisgeloup period, and the assistance given by González. Picasso did not go to Boisgeloup until 1931.

10 D.-H. Kahnweiler, *The Sculptures of Picasso*, London (Rodney Phillips), 1949, p. 7.

11 Ill. Kahnweiler, *ibid.*, pls. 9–11.

12 Ill. Camilla Gray, *The Great Experiment: Russian Art 1863–1922*, London (Thames & Hudson), 1962, pls. 121–5. All students of modern art are greatly indebted to this work, which for the first time gave a clear indication to the outer world of the course of artistic events in Russia up to 1922.

13 Cf. Camilla Gray, *ibid.*, pp. 184–5.

14 Cf. Camilla Gray, *ibid.*, pp. 147–8.

15 A Russian translation of Chapter VI of Kandinsky's *Über das Geistige in der Kunst* was published in 1912. Extracts had been read to a Congress of Russian Artists held in St Petersburg on 29–31 December 1911.

16 Cf. Camilla Gray, *op. cit.*, p. 219.

17 Ill. Camilla Gray, *op. cit.*, pls. 174–7, 179.

18 *Bauhaus 1919–1928*, ed. Herbert Bayer, Walter Gropius, Ise Gropius, New York and London (Allen & Unwin), 1939, p. 18.

19 From a letter to Antony Kok. Cf. *de Stijl*, cat. 81, Stedelijk Museum, Amsterdam, 1951, p. 45.

20 'An intimate biography', catalogue of an exhibition of Vantongerloo's work at the Marlborough New London Gallery, November 1962. Ed. Max Bill, pp. 52–4.

21 *Bauhaus 1919–1928*, *op. cit.*, p. 124.

22 Sibyl Moholy-Nagy, *Moholy-Nagy: experiment in totality*, New York, 1950, p. 205.

23 *The Art of Sculpture*, New York (Bollingen Series) and London (Faber & Faber), 1956, p. 71.

24 'Constructive Art: an Exchange of Letters between Naum Gabo and Herbert Read', *Horizon*, London, vol. x, No. 55, July 1944. Reprinted in *Gabo: Constructions Sculpture Paintings Drawings Engravings*, London (Lund Humphries), 1957, p. 171.

Chapter Four

1 Joshua C. Taylor, *Futurism* (New York Museum of Modern Art), 1961. Appendix B, p. 134, trans. Margaret Scolari Barr.

2 *Ibid.*, p. 134.

3 *Ibid.*, p. 87.

4 The earlier date is given by Carola Giedion-Welcker, *Contemporary Sculpture*, New York (George Wittenborn Inc.) and London (Faber & Faber), 1961, p. 65; the later date by Taylor, *op. cit.*, p. 101.

5 D.-H. Kahnweiler, *The Rise of Cubism*, trans. Henry Aronson, New York, 1949, pp. 21–2.

6 Read, *op. cit.*, pp. 119–20.

7 *Arp*, edited with an introduction by James Thrall Soby, articles by Jean Hans Arp, Richard Huelsenbeck, Robert Melville, Carola Giedion-Welcker. New York (Museum of Modern Art), 1958, p. 13.

8 *Essays on Contemporary Events*, London (Kegan Paul), 1947, pp. 9–10.

9 Ill. C. Giedion-Welcker, *op. cit.*, p. 91, where also an *Objet Dad' Art* of 1919–20 by Max Ernst is illustrated. This too has not survived.

10 Robert Lebel, *Marcel Duchamp*. With chapters by Marcel Duchamp, André Breton and H. P. Roché. Trans. G. H. Hamilton, New York (Trianon Press), 1959; London (Collins), 1960.

11 *Ibid.*, p. 36.

12 'Souvenirs' of H. P. Roché, in Lebel, *ibid.*, p. 84.

13 'Limits not Frontiers of Surrealism', *Surrealism*, London, 1936, p. 103.

14 *Charbon d'Herbe*, Paris, 1933. Quoted from C. Giedion-Welcker, *op. cit.*, p. 97.

15 *Ibid.*, p. 98. From *Minotaure*, 1933.

16 'Les peintures de Giacometti', *Derrière le miroir*, No. 65, May 1954.

17 C. Giedion-Welcker, *op. cit.*, p. 300.

Chapter Five

1 *Sculpture & Drawings*, vol. 1 (1957), p. xxxi. Originally contributed to *Unit One*, ed. Herbert Read, London, 1934.

2 *Picasso: Fifty Years of his Art*, New York (Museum of Modern Art), 1946, p. 150.

3 *Sculptures & Drawings*, vol. 1, p. xxxiv. First published in *The Listener*, 18 August 1937.

4 *Ibid.*

5 A recollection of Brancusi's own statement by A. Istrati, recorded by Ionel Jianou in *Brancusi*, London (Adam Books), 1963, p. 68.

6 *Ibid.*, p. 69.

7 *Ibid.*, p. 67.

8 *Barbara Hepworth: Carvings & Drawings*, with an Introduction by Herbert Read, London (Lund Humphries), 1952.

9 Giacometti's letter to Pierre Matisse, 1947.

10 *Creative Development: Five Lectures to Students*, London (Routledge & Kegan Paul), 1962, p. 58.

11 *Zeugnisse der Angst in der modernen Kunst.* Catalogue published by Professor Dr Hans-Gerhard Evers. Darmstadt, 1963, p. 97.

Chapter Six

1 'On Art Movements', *The New Yorker*, 5 October 1963, pp. 159–69.

2 *A Philosophical Enquiry into the Origin of our Ideas of the Sublime and the Beautiful.* Part III, p. xxi.

3 I have discussed the problem in 'Beauty and the Beast', *Eranos Jahrbuch*, Zurich, 1961, vol. xxx, pp. 175–210.

4 William C. Seitz, *The Art of Assemblage*, New York (Museum of Modern Art), 1961, p. 68. This volume gives a very complete survey of all this art of transformed 'ready-mades'.

5 Pierre Restany, from an exhibition catalogue, Hanover Gallery, London, 1960. Quoted by Seitz, *op. cit.*, p. 145.

6 *Giotto and his Works in Padua* (1854), p. 23.

Select Bibliography

A very comprehensive bibliography of modern sculpture has been compiled by Bernard Karpel of the Museum of Modern Art, New York, and is printed in Carola Giedion-Welcker's *Contemporary Sculpture* (see below). In this more select bibliography I have included only those books which the general reader might find useful for the further study of the subject.

General Works on the History and Theory of Sculpture

BARR, Alfred H. Jr.: *Cubism and Abstract Art.* passim ill. New York (Museum of Modern Art), 1936.

FOCILLON, Henri: *The Life of Forms in Art.* 94 pp. ill. New York (Wittenborn, Schultz, Inc.), 1948.

GIEDION-WELCKER, Carola: *Contemporary Sculpture: an Evolution in Volume and Space.* 397 pp. ill. New York (George Wittenborn, Inc.) and London (Faber & Faber), revised edition, 1961.

HILDEBRAND, Adolf: *The Problem of Form in Painting and Sculpture.* Trans. by Max Meyer and Robert Morris Ogden. New York (Haffner Publishing Company), 1945.

MAILLARD, Robert (ed.): *A Dictionary of Modern Sculpture.* 320 pp. ill. London (Methuen), 1962.

MOHOLY-NAGY, L.: *The New Vision.* 397 pp. ill. London and New York, revised edition, 1939. Latest edition, New York (Wittenborn, Schultz, Inc.), 1955.

RAMSDEN, E. H.: *Sculpture: Theme and Variations.* 56 pp. plus 103 ill. London (Lund Humphries), 1953.

READ, Herbert: *Art Now: an Introduction to the Theory of Modern Painting and Sculpture.* 128 pp. ill. Paperback edition, London (Faber & Faber), 1963.

READ, Herbert: *The Meaning of Art.* 197 pp. ill. London (Faber & Faber and Penguin Books). Latest edition, 1963.

READ, Herbert: *The Art of Sculpture.* 152 pp. ill. New York (Bollingen Series) and London (Faber & Faber), 1956.

RITCHIE, Andrew C.: *Sculpture of the Twentieth Century.* 238 pp. ill. New York (Museum of Modern Art) and London (Mayflower Books), 1953.

SEYMOUR, Charles: *Tradition and Experiment in Modern Sculpture.* 86 pp. ill. Washington, D.C. (American University Press), 1949.

VALENTINER, W. R.: *Origins of Modern Sculpture.* 180 pp. ill. New York (Wittenborn, Schultz, Inc.), 1946.

WILENSKI, Reginald H.: *The Meaning of Modern Sculpture.* pp. 83–164, ill. New York (Stokes) and London (Faber & Faber), 1935.

Particular Studies

AGUILERA–CERNI, Vicente: *Julio González*. Vol. 1 of the series 'Contributi alla storia dell'Arte', ed. Giuseppe Gatt. Rome (Edizione dell'Ateneo), 1962.

BARR, Alfred H. Jr.: *Matisse: His Art and His Public.* 591 pp. ill. New York (Museum of Modern Art), 1951.

BOCCIONI, Umberto: *Manifeste technique de la sculpture futuriste,* 11 April 1912.

ELSEN, Albert E.: *Rodin.* 228 pp. ill. New York (Museum of Modern Art), 1963.

GABO, Naum: *A Retrospective View of Constructive Art.* In 'Three Lectures on Modern Art', pp. 65–87. New York (Philosophical Library), 1949.

Gabo; Constructions Sculpture Paintings Drawings Engravings. With introductory essays by Herbert Read and Leslie Martin. 193 pp. ill. London (Lund Humphries), 1957.

Naum Gabo – Antoine Pevsner. With an Introduction by Herbert Read. Texts by Ruth Olson and Abraham Chanin. 84 pp. ill. New York (Museum of Modern Art), 1948.

GIEDION-WELCKER, Carola: *Constantin Brancusi.* New York (Braziller) and London (Mayflower Books), 1959.

Julio González, Sculptures. 23 pp. ill. Paris, Musée National d'Art Moderne (Éd. des Musées nationaux), 1952.

Julio González. 48 pp. ill. New York (Museum of Modern Art), 1958.

GRAY, Camilla: *The Great Experiment: Russian Art, 1863–1922.* 327 pp.

ill. London (Thames & Hudson), 1962.

GROHMANN, W.: *Henry Moore.* Berlin (Rembrandt) and London (Thames & Hudson), 1960.

HAMMACHER, A. M.: *Barbara Hepworth.* London (Thames & Hudson), 1968.

HEPWORTH, Barbara: *Barbara Hepworth, Carvings and Drawings.* With an Introduction by Herbert Read. 30 pp., 165 pl. London (Lund Humphries), 1952.

HODIN, J. P.: *Barbara Hepworth.* New York and London (Lund Humphries), 1962.

JIANOU, Ionel: *Brancusi.* 223 pp. ill. London (Adam Books), 1963.

KAHNWEILER, Daniel-Henry: *The Sculptures of Picasso.* Photographs by Brassaï. 8 pp. plus 218 pl. London (Rodney Phillips), 1949.

LEBEL, Robert: *Marcel Duchamp.* Trans. G. H. Hamilton. 192 pp. ill. New York (Trianon Press), 1959; London (Collins), 1960.

Modern Sculpture from the Joseph H. Hirshhorn Collection. 246 pp. ill. New York (The Solomon R. Guggenheim Museum), 1962.

MOTHERWELL, Robert (ed.): *The Dada Painters and Poets.* pp. 136–40, 185–6, 207–11, 255–63, 306–15, 356–7 et passim ill. New York (Wittenborn, Schultz, Inc.), 1951.

PENROSE, Roland: *Modern Sculptors; Picasso.* 16 pp., 32 ill. London (Zwemmer), 1961.

READ, Herbert: *Henry Moore.* London (Zwemmer), 1934.

READ, Herbert: *Henry Moore, Sculpture and Drawings.* Vol. 1, xliii + 278 pp. ill. 4th edition, 1957; vol. II, xxiv + 116 pp. ill., 2nd

edition, 1965. London (Lund Humphries). Vol. III in preparation.

READ, Herbert: *Henry Moore.* London (Thames & Hudson), 1965.

REWALD, John: *Degas: Works in Sculpture.* 124 pp. 112 pl. New York (Pantheon), 1944.

RITCHIE, Andrew C.: *Abstract Painting and Sculpture in America.* 159 pp. ill. New York (Museum of Modern Art), 1951.

RODIN, Auguste: *L'Art – entretiens réunis par Paul Gsell.* 318 pp. ill. Paris (Grasset), 1911; Lausanne (Mermod), 1946.

Sculpture of the Twentieth Century. 240 pp. ill. New York (Museum of Modern Art) and London (Mayflower Books), 1958.

SEITZ, William C.: *The Art of Assemblage.* 176 pp. ill. New York (Museum of Modern Art), 1961.

SOBY, James Thrall (ed.): *Jean Arp.* 126 pp. ill. New York (Museum of Modern Art), 1958.

SWEENEY, James Johnson: *Alexander Calder.* New York (Museum of Modern Art), 1951.

The Unknown Political Prisoner. International Sculpture Competition sponsored by the Institute of Contemporary Arts. 24 pp. ill. London (Tate Gallery), 1953.

The following more recent works, both general and particular, may also prove useful:

BURNHAM, Jack: *Beyond Modern Sculpture.* xii + 402 pp., ill. New York (George Braziller), 1968.

GEIST, Sidney: *Brancusi. A Study of the Sculpture.* 248 pp., ill. London (Studio Vista), 1968.

GRAY, Christopher: *Sculpture and Ceramics of Paul Gauguin.* Baltimore (The John Hopkins Press), 1963.

HAMMACHER, A. M.: *The Evolution of Modern Sculpture.* 383 pp., ill. London (Thames & Hudson), 1969.

HEPWORTH, Barbara: *The Complete Sculpture of Barbara Hepworth 1960–69* ed. Alan Bowness. 50 pp. + 167 pp. ill. London (Lund Humphries), 1971.

READ, Herbert: *Arp.* 216 pp., ill. London (Thames & Hudson), 1968.

285

List of Works Reproduced

Entries are listed alphabetically under the names of artists. Measurements are given in inches, followed by centimetres within brackets. When three dimensions are given, these appear in the following order: height, width, depth. Each entry is followed by its plate number.

ADAM, Henri-Georges (b. Paris, 1904)
Trois Pointes. 1959
Bronze. 17¾ × 13¾ (45 × 35)
Collection the artist
Photo Pierre Joly—Véra Cardot, Paris
324

ADAMS, Robert (b. Northampton, England, 1917)
Maquette for architectural Screen. 1956
Bronze. 29½ × 9 (75 × 23)
Collection and photo Gimpel Fils, London
235

AESCHBACHER, Hans (b. Zurich, 1906)
Figure XI. 1960
Brass. H.9⅞ (25)
Collection and photo the artist
232

AGOSTINI, Peter (b. New York, 1913)
Hurricane Veronica. 1962
Plaster. H.55¼ (140·5)
Collection Stephen Radich Gallery, New York
314

ANTHOONS, Willy (b. Mechlin, Belgium, 1911)
Infinite Form. 1949–60
Euville stone. H.63 (160)
Rijksmuseum Kröller-Müller, Otterlo
190

ARCHIPENKO, Alexander (Kiev, 1887—New York, 1964)
Seated Mother. 1911
Bronze. H. including base 23⅝ (60)
Stadt Kunstmuseum, Duisburg
73

ARCHIPENKO, Alexander
Boxing Match. 1913
Terracotta. H.31⅛ (79)
Collection Peggy Guggenheim, Venice
Photo Peter Cannon Brookes, London
124

ARCHIPENKO, Alexander
Woman with a Fan. 1914
Bronze polychrome. H.25⅝ (65)
70

ARMITAGE, Kenneth (b. Leeds, 1916)
Walking Group. 1951
Bronze. H.9 (23)
254

ARMITAGE, Kenneth
Figure lying on its side (5th version). 1958–9
Bronze. L.32 (81·3)
Collection British Council, London
Photo Lidbrooke, London
255

ARMITAGE, Kenneth
Slab Figure. 1961
Bronze. 28½ × 38 (72 × 97)
Collection Marlborough Fine Art Limited, London
Photo Harriet Crowder, London
256

ARP, Hans (Jean) (Strasbourg, 1887—Basel, 1966)
Madame Torso with wavy Hat. 1916
Wood 15⅞ × 10⅜ (40·5 × 26·5)
Rupf Foundation, Berne
132

ARP, Hans (Jean)
Forest. 1916
Painted wood. 12⅝ × 8¼ (32 × 21)
Collection Roland Penrose, London
Photo John Webb, London
133

ARP, Hans (Jean)
Shell and Head. 1933
Bronze. 7⅞ × 9⅞ × 7¼ (20 × 25 × 18·5)
Collection Peggy Guggenheim, Venice
Photo Peter Cannon Brookes, London
51

ARP, Hans (Jean)
Human Concretion. 1933
Bronze. 29½ × 22 × 13⅜ (75 × 56 × 34)
Photo Étienne Bertrand Weill, Paris
85

ARP, Hans (Jean)
Landmark. 1938
Wood lathe-turned and sawn. 23⅝ × 9⅞ × 14⅛ (60 × 25 × 36)
Collection the artist
Photo Étienne Bertrand Weill, Paris
48

287

288

BRUNI, Lev
Construction. *c*. 1918. Wood
Photo Camilla Gray, London 93

BUTLER, Reg (b. Buntingford, 1913)
Project for Monument to the Unknown
Political Prisoner. 1951–2
Bronze wire and metal maquette, welded
on to stone base. H.17¼ (43·5)
Private Collection, USA
Photo John R. Pantlin 215

BUTLER, Reg
Study for a great Tower. 1963
Bronze. H.14½ (36·5)
Collection the artist
Photo John Webb, London 216

CALDER, Alexander (b. Philadelphia,
1898)
Calderberry Bush. 1932
Standing mobile, steel wire and rod, sheet
aluminium and wood. H.84 (213·5)
Collection Mr and Mrs James Johnson
Sweeney, New York
Photo Leonard De Caro, New York 67

CALDER, Alexander
Stabile (Le petit Nez). 1959
Black metal. H.66⅝ (169)
Collection Joseph H. Hirshhorn, New
York
Photo The Solomon R. Guggenheim
Museum, New York 290

CALLERY, Mary (b. New York, 1903)
A. 1960
Brass and steel. 15 × 9 (38 × 23)
Collection M. Knoedler & Co., New York
Photo Gauthier, Paris 288

CARO, Anthony (b. London, 1924)
Lock. 1962
Painted steel coloured blue. 34½ × 120 ×
111 (87·5 × 304·5 × 282)
Collection Kasmin Ltd, London 279

CASCELLA, Andrea (b. Pescara, 1920)
The White Bride
White marble. 24 × 14½ × 14½ (61 × 37 ×
37)
Grosvenor Gallery, London 189

CASCELLA, Pietro (b. Pescara, 1921)
Pygmalion. 1963
Stone. 47¼ × 23⅝ (120 × 60)
Galerie du Dragon, Paris 192

CÉSAR (César Baldaccini) (b. Marseilles,
1921)
The Man of Saint-Denis. 1958
Welded iron. Including base 20⅛ × 43⅛
(51 × 109·5)
Tate Gallery, London 264

CÉSAR
Relief. 1961
Compressed automobile. 86⅝ × 78¾ (220 ×
200)
Galerie Claude Bernard, Paris 336

CHADWICK, Lynn (b. London, 1914)
The Watchers. 1960
Bronze. H.92 (233·5)
Collection London County Council
Photo David Farrell, Gloucester 212

CHADWICK, Lynn
Winged Figures. 1962
Painted iron. 120 × 216 (305 × 549)
Collection the artist
Photo John Webb, London 213

CHAMBERLAIN, John (b. Rochester,
Indiana, 1927)
Untitled. 1960
Welded metal. 20 × 16 × 12 (50·5 × 40·5 ×
30·5)
Collection Joseph H. Hirshhorn, New
York
Photo Robert E. Mates, New York 335

CHILLIDA, Eduardo (b. St Sebastian,
Spain, 1924)
Enclume de Rêve, no. 10. 1962
Iron on wooden base. H.58¾ (149·5). H.
without base 17 (43·5)
Oeffentliche Kunstsammlung, Basle 299

CLARKE, Geoffrey (b. Darley Dale,
England, 1924)
Battersea Group. 1962
Sandcast pure aluminium. (1) 42 × 138 × 36
(106·5 × 351 × 92); (2) 30 × 126 × 54 (77
× 320 × 137); (3) 48 × 156 × 42 (122 ×
397 × 106)
Collection the artist
Photo Crispin Eurich 176

CLATWORTHY, Robert (b. Somerset,
England, 1928)
Bull. 1956–7
Bronze. H. including base 63 (160)
Collection London County Council
Photo Penny Tweedie, London 253

292

293

KOLLWITZ, Käthe (Kaliningrad, Russia, 1867—Moritzburg, Germany, 1945)
The Complaint. 1938
Bronze. 10¼ × 9⅞ (26·5 × 25)
Photo Bayerische Staatsgemäldesammlungen, Munich 15

KOMAN, Ilhan (b. Edirne, Turkey, 1921)
Miroir II. 1962
Iron. H.31½ (80)
Collection the artist 323

KOWALSKI, Piotr (b. Warsaw, 1927)
Calotte 4. 1961
Concrete (5 pieces). H.11 (28)
Kunsthalle, Berne
Photo Kurt Blum, Berne 200

KRICKE, Norbert (b. Düsseldorf, 1922)
Space Sculpture. 1960
Steel. H.27⅝ (70)
Collection Countess Jean de Beaumont, Paris
Photo Galerie Karl Flinker, Paris 287

LARDERA, Berto (b. La Spezia, Italy, 1911)
Slancio temerario, no. 2. 1958–9
Iron, steel and copper
Galerije Grada Zagreba, Zagreb 291

LASSAW, Ibram (b. Alexandria, 1913)
Counterpoint Castle. 1957
Bronze and copper. H.39 (106·5)
Kootz Gallery, New York 281

LAURENS, Henri (Paris, 1885—Paris, 1954)
Composition in black and red sheet iron. 1914
8 × 11¾ (20·5 × 30)
Collection Madame Maurice Raynal, Paris
 115
LAURENS, Henri
Head. 1917
Stone. H.25⅝ (65)
Stedelijk Museum, Amsterdam 71

LAURENS, Henri
Reclining Woman with raised arms. 1949
Bronze. L.10½ (26·5)
Hanover Gallery, London 87

LE CORBUSIER, Charles Edouard (La Chaux-de-Fonds, Switzerland, 1887–1965)
Ozon, Op. 1, 1947
Painted wood. H. 27⅝ (70)
Private Collection, Paris
Photo Kurt Blum, Berne 105

LEHMBRUCK, Wilhelm (Meiderick, near Duisburg, 1881—Berlin, 1919)
Young Man Seated. 1918
Bronze. H.41 (104)
Stadt Kunstmuseum, Duisburg 13

LEONCILLO, Leonardi (b. Spoleto, Italy, 1915)
Sentimento del tempo. 1961
Red sandstone and enamel. 63 × 19⅝ × 21⅝ (160 × 50 × 55)
Galleria l'Attico, Rome 329

LIPCHITZ, Jacques (b. Druskieniki, Lithuania, 1891)
Head. 1915
Bronze. H.24½ (62·5)
Collection Joseph H. Hirshhorn, New York
 75

LIPCHITZ, Jacques
Guitar Player. 1918
Bronze. H.28¾ (72)
Stadt Kunstmuseum, Duisburg 76

LIPCHITZ, Jacques
Figure. 1926–30
Bronze. H.85¼ (217)
Collection Joseph H. Hirshhorn, New York
Photo The Solomon R. Guggenheim Museum, New York 79

LIPCHITZ, Jacques
Reclining Nude with Guitar. 1928
Bronze. L.27 (68·5)
Collection Joseph H. Hirshhorn, New York
Photo The Solomon R. Guggenheim Museum, New York 166

LIPCHITZ, Jacques
Benediction I. 1942
Bronze. H.42 (106·5)
Collection Mr and Mrs Bernard J. Reis, New York
Photo Eric Pollitzer, New York 84

LIPPOLD, Richard (b. Milwaukee, USA, 1915)
Variations within a Sphere, no. 10: The Sun. 1953–6
Gold wire. 263¾ × 131⅞ × 65⅞ (670 × 335 × 167)
Fletcher Fund, The Metropolitan Museum of Art, New York 286

297

299

ROSATI, James (b. Washington, Penn., 1912)
Delphi IV. 1961
Bronze. H.27½ (69·5)
Marlborough-Gerson Gallery, New York
Photo Rudolph Burckhardt, New York
197

ROSENTHAL, Bernard (b. Highland Park, Illinois, 1914)
Riverrun. 1959
Black aluminium. 87×57⅝ (221×151·5)
333

ROSSO, Medardo (Turin, 1858—Milan, 1928)
Ecce Puer. 1906-7
Wax over plaster. H.17 (43·5)
Collection Mr and Mrs Harry Lewis Winston, Detroit
Photo Oliver Baker, New York 7

ROSSO, Medardo
Conversazione in Giardino. 1893
Bronze. 13×26⅜×15⅞ (33×67×40·5)
Galleria Nazionale d'Arte Moderna, Rome
3

ROSZAK, Theodore (b. Poznan, Poland, 1907)
Night Flight. 1958-62
Steel. 92×125 (238·5×317·5)
Collection the artist
Photo Pierre Matisse Gallery, New York
241

RUGG, Matt (b. Bridgwater, England, 1935)
Boomerang. 1963
Wood construction. 39¾×36¾ (101×93·5)
Collection John Hubbard, Dorset 337

SALVATORE (Messina Salvatore) (b. Palermo, 1916)
Corrida
Bronze. 94½×70⅞ (240×180) 181

SCHLEEH, Hans (b. Koenigsberg, Germany, 1928)
Abstract Form in Serpentine.
27½×15×7½ (69·5×38×19)
Dominion Gallery, Montreal 194

SCHLEMMER, Oskar (Stuttgart, 1888—Baden-Baden, 1943)
Abstrakte Rindplastik. 1921
Bronze gilded. H.41 (104·5)
Bayerische Staatsgemäldesammlungen, Munich 121

SCHMIDT, Julius (b. Stamford, Conn., 1923)
Cast Iron. 1961
18½×38½ (47×97·5)
Marlborough-Gerson Gallery, New York
Photo Rudolph Burckhardt, New York
265

SCHNIER, Jacques (b. Constanza, Rumania, 1898)
Cubical Variations within rectangular Column. 1961
Copper. 83×14×12 (210·5×35·5×30·5)
Collection the artist 233

SCHÖFFER, Nicolas (b. Kolosca, Hungary, 1912)
Spatiodynamique no. 19. 1953
Brass and iron. 39¾×28×32⅝ (101×71×83)
Galerie Denise René, Paris 231

SCHWITTERS, Kurt (Hanover, 1887—Ambleside, England, 1948)
Merzbau. Begun 1920, destroyed 1943
Photo Landesgalerie, Hanover 125

SCHWITTERS, Kurt
Autumn Crocus. 1926-8
Cast. Composition stone. H.31½ (80)
Lord's Gallery, London
Photo John Webb, London 126

SCHWITTERS, Kurt
Ugly Girl. c. 1943-5
Painted wood and plaster. 10¼×12¼×9¼ (26×31×23·5)
Lord's Gallery, London
Photo John Webb, London 127

SELEY, Jason (b. Newark, New Jersey, USA, 1919)
Magister Ludi. 1962
Chrome-plated steel (car bumpers). H.96 (243·5)
Collection Governor Nelson D. Rockefeller, New York
Photo John Webb, London 267

SINTENIS, Renée (b. Glatz, Poland, 1888)
Football Player. 1927
Bronze. H.16 (40·5)
Rijksmuseum Kröller-Müller, Otterlo 14

303

SMITH, David (Decatur, USA, 1906–
Albany, USA, 1965)
Royal Bird. 1948
Stainless steel. 21¾×59×9 (55·5×150×
23)
Walker Art Center, Minneapolis 217

SMITH, David
Cubi IX. 1961
Steel. 107×51½ (271·5×130·5)
Collection the artist
Photo John Webb, London 218

SOMAINI, Francesco (b. Lomazzo,
Como, 1926)
Grand Blessé, no. 1. 1960
Lead (unique piece). 34×60×45 (86·5×
152·5×114·5). H. including base 72
(183)
Collection Mr and Mrs Harry Lewis
Winston, Detroit
Photo Joseph Klima Jr. 313

STAHLY, François (b. Konstanz, Ger-
many, 1911)
Model for a Fountain for the University of
St Gall, Switzerland
Bronze. H.236¼ (600)
Photo Leni Iselin 220

STANKIEWICZ, Richard (b. Phila-
delphia, 1922)
Untitled. 1961
Iron and steel. H.84 (213·5)
Stable Gallery, New York
Photo John Webb, London 278

STARTUP, Peter (b. London, 1921)
Falling Figure. 1960
Lime, sycamore and pine. H.90 (228·5)
Collection the artist
Photo Alfred Lammer, London 223

TAJIRI, Shinkichi G. (b. Los Angeles,
1923)
Relic from an Ossuary. 1957
Bronze. H.13¾ (35)
Collection the artist 312

TATLIN, Vladimir Evgrafovich
(Kharkov, 1885—Moscow, 1953)
Relief. 1915
Iron etc.
Whereabouts unknown. Presumed
destroyed
Photo Camilla Gray, London 89

TATLIN, Vladimir
Relief. 1914
Wood, glass, tin can etc.
Whereabouts unknown. Presumed des-
troyed
Photo Camilla Gray, London 91

TATLIN, Vladimir
Monument to the Third International.
1919–20
Wood, iron, glass
Remnants of this maquette are stored in
the Russian Museum, Leningrad
Photo Camilla Gray, London 96

TAUEBER-ARP, Sophie (Davos, Swit-
zerland, 1889—Zurich, 1943)
Last Construction, no. 8. 1942
Bronze relief. 14×14 (35·5×35·5)
Galerie Denise René, Paris
Photo Étienne Bertrand Weill, Paris
 129

TEANA, Marino di (b. Teana, Italy,
1920)
Espace et Masse libérés – hommage à
l'architecture. 1957
Steel. 41⅜×45¼×15¾ (105×120×40)
Galerie Denise René, Paris 237

THOMMESEN, Erik (b. Copenhagen,
1916)
Woman. 1961
Black oak. H.60⅝ (154)
Louisiana Museum 202

THORNTON, Leslie (b. Skipton, Eng-
land, 1925)
The Martyr. 1961
Steel and bronze. H.69½ (176·5)
Collection and photo Gimpel Fils,
London 310

TINGUELY, Jean (b. Basle, 1925)
Monstranz. 1960
Junk-mobile. H.36 (91·5)
Staempfli Gallery, New York
Photo John D. Schiff, New York 311

TURNBULL, William (b. Dundee, 1922)
Llama. 1961
Bronze and rosewood. H.61 (155)
Private Collection, USA
Photo Kim Lim 204

TURNBULL, William
Oedipus. 1962
Bronze, rosewood and stone. H.65½ (166·5)
Collection Weiner, USA
Photo Kim Lim 205

304

Index

Italic figures refer to pages on which illustrations appear